Mexican Tattoo Design Book

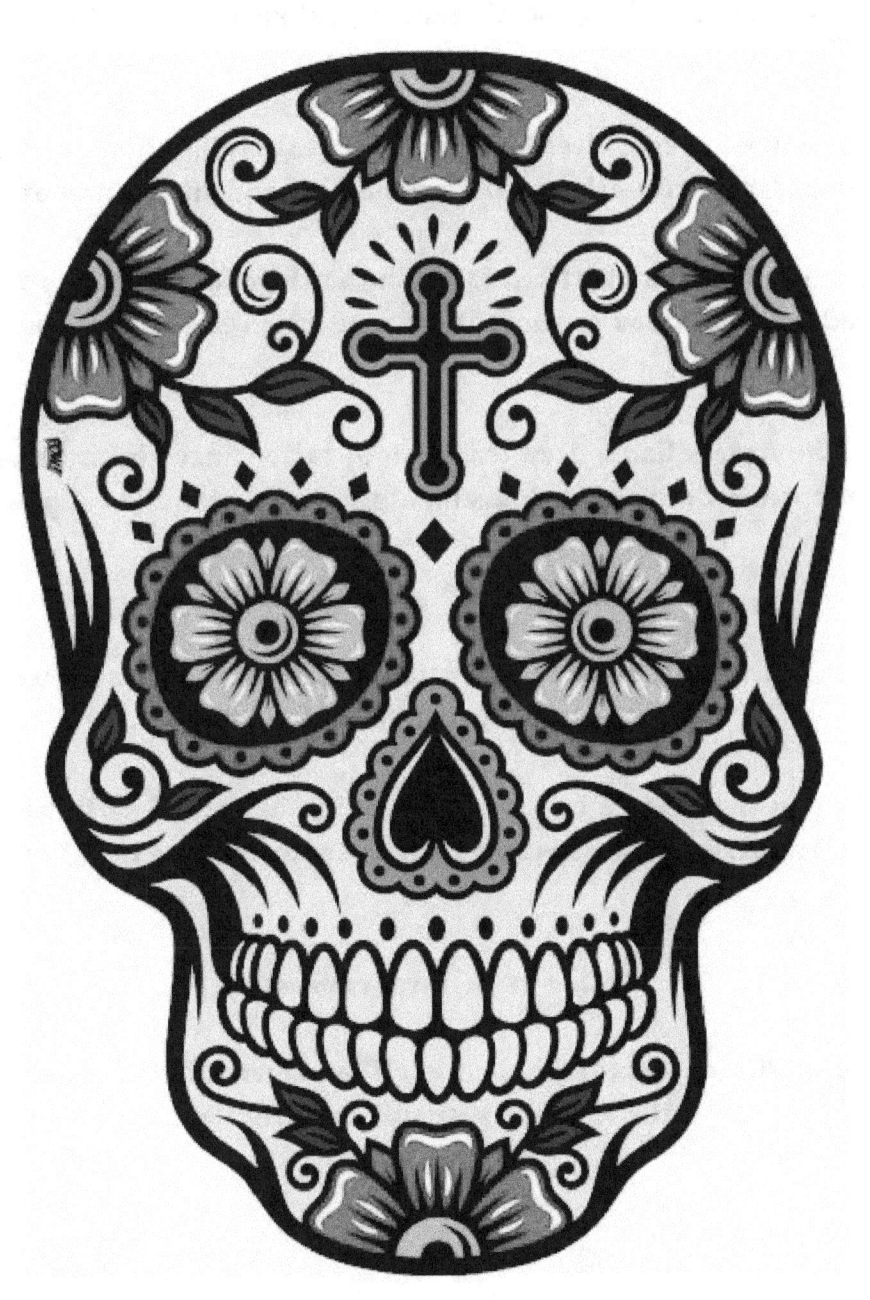

Pre-Hispanic origins

The art of tattooing has deep roots in the pre-Hispanic cultures of Mexico. Tattoos in ancient Mesoamerica had spiritual, social and cultural meaning, and were used for various purposes:

Olmec Culture: The Olmecs, considered one of the oldest civilizations in Mesoamerica, had a tattoo tradition associated with social status and the identification of specific groups.

Mayan Culture: The Mayans practiced tattooing with religious and symbolic meaning. Priests and leaders got tattoos to show their connection to the gods and their elevated status.

Aztec Culture: The Aztecs had a deep tradition of tattoos used by warriors, priests and nobles to represent military achievements, social ranks and religious beliefs.

Stigmatization and resurgence

After the Conquest, tattoos in Mexico were stigmatized and associated with criminals and marginalized people for a long time.

However, starting in the 1990s, a tattoo revival began in Mexico, with the opening of the first professional studios in Mexico City, such as Tattoomania in 1993 and Dermafilia in 1994.

Tattoo as cultural expression

Today, tattooing in Mexico has established itself as a form of expression and connection with the rich pre-Hispanic cultural heritage.

The different elements of Mexican tattoos have deep meanings rooted in the country's history and culture. Some of the most common meanings include:

Elements of nature and animals

Eagle: Symbol of power, freedom and connection with the divine in Aztec culture.

Jaguar: Sacred animal that represents strength, bravery and connection with the spiritual world.

Feathered Serpent: Symbol of wisdom, balance and rebirth in Aztec mythology.

Axolotl: Amphibian endemic to Mexico, now in danger of extinction, which symbolizes the connection with nature.

Corn: Sacred food related to the sun, energy and fertility in pre-Hispanic cultures.

Nopal: Plant with multiple uses, it represents resilience and adaptation to adverse environments.

Religious and spiritual symbols

Feathers: They symbolize freedom, wisdom and sacred values in Aztec culture.

Coatlicue: Goddess of fertility and the earth, mother of the Aztec gods.

Quetzalcóatl: God of creator and wisdom, represents the balance between opposites.

Popular iconography

Skulls: Symbols of death and life, they celebrate existence and honor ancestors.

Frida Kahlo: Icon of Mexican art, she symbolizes strength, creativity and national pride.

Katrina: Catrina symbolizes the passage to the afterlife and the acceptance of death as a natural part of life.

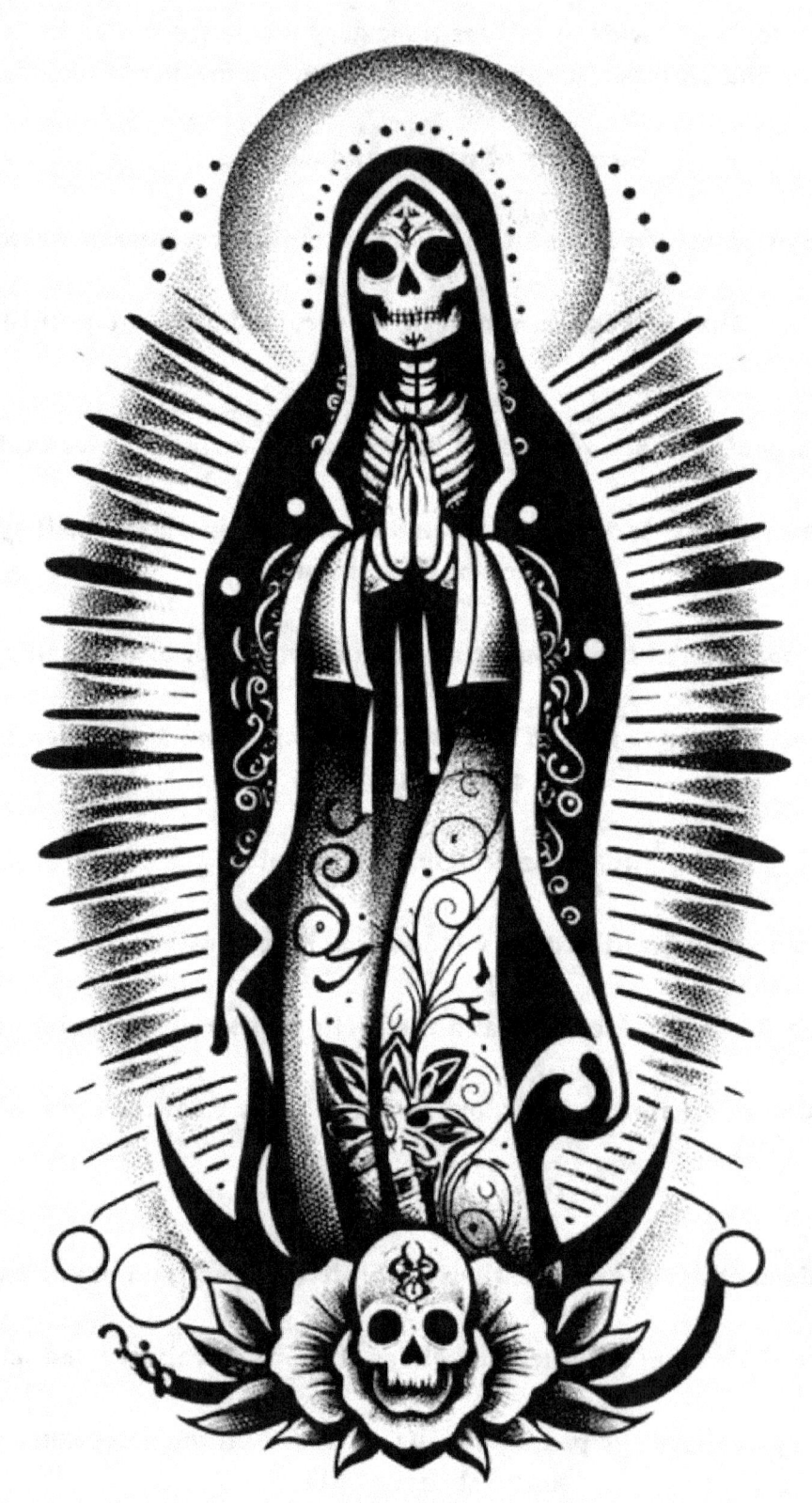

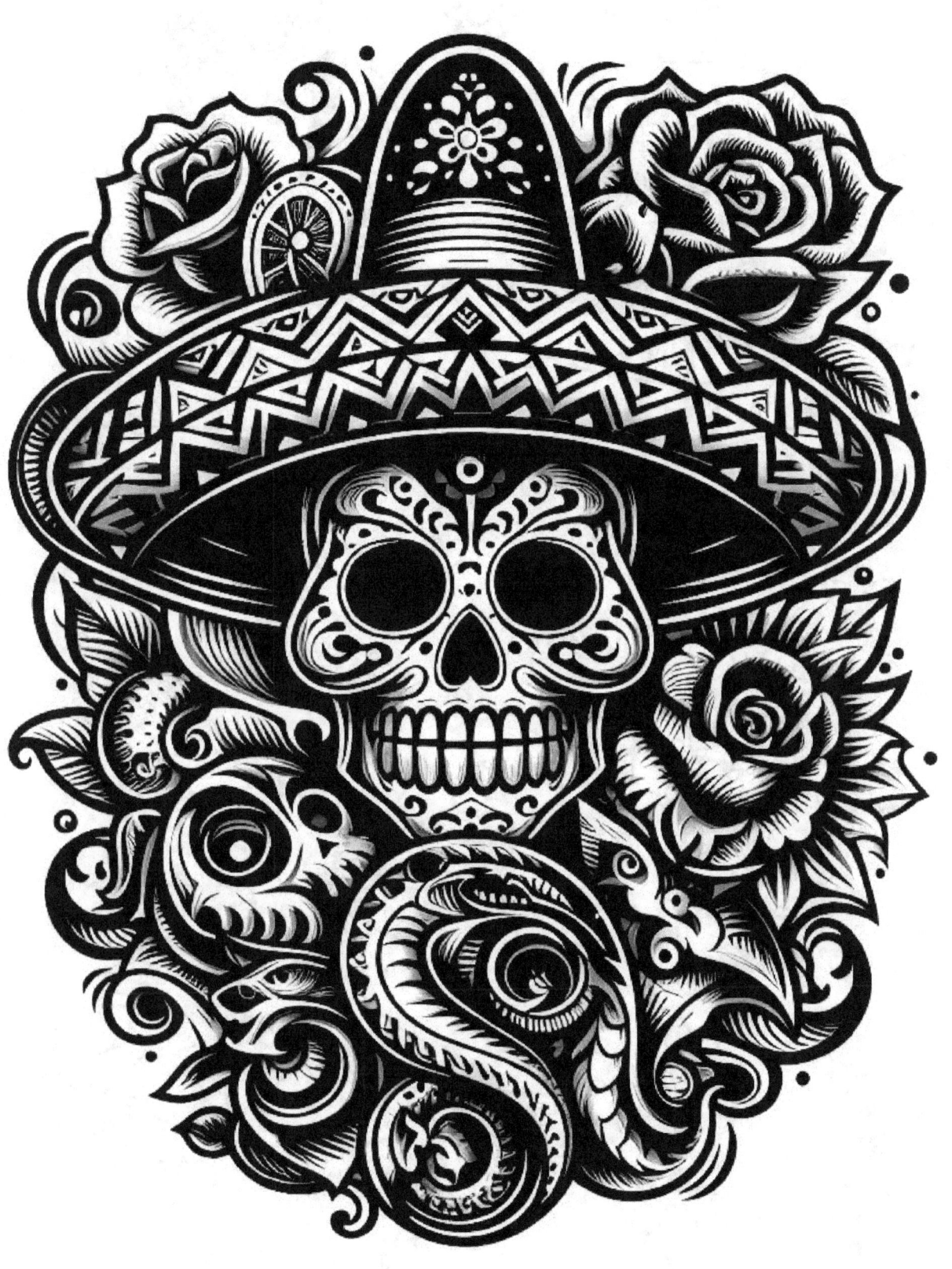

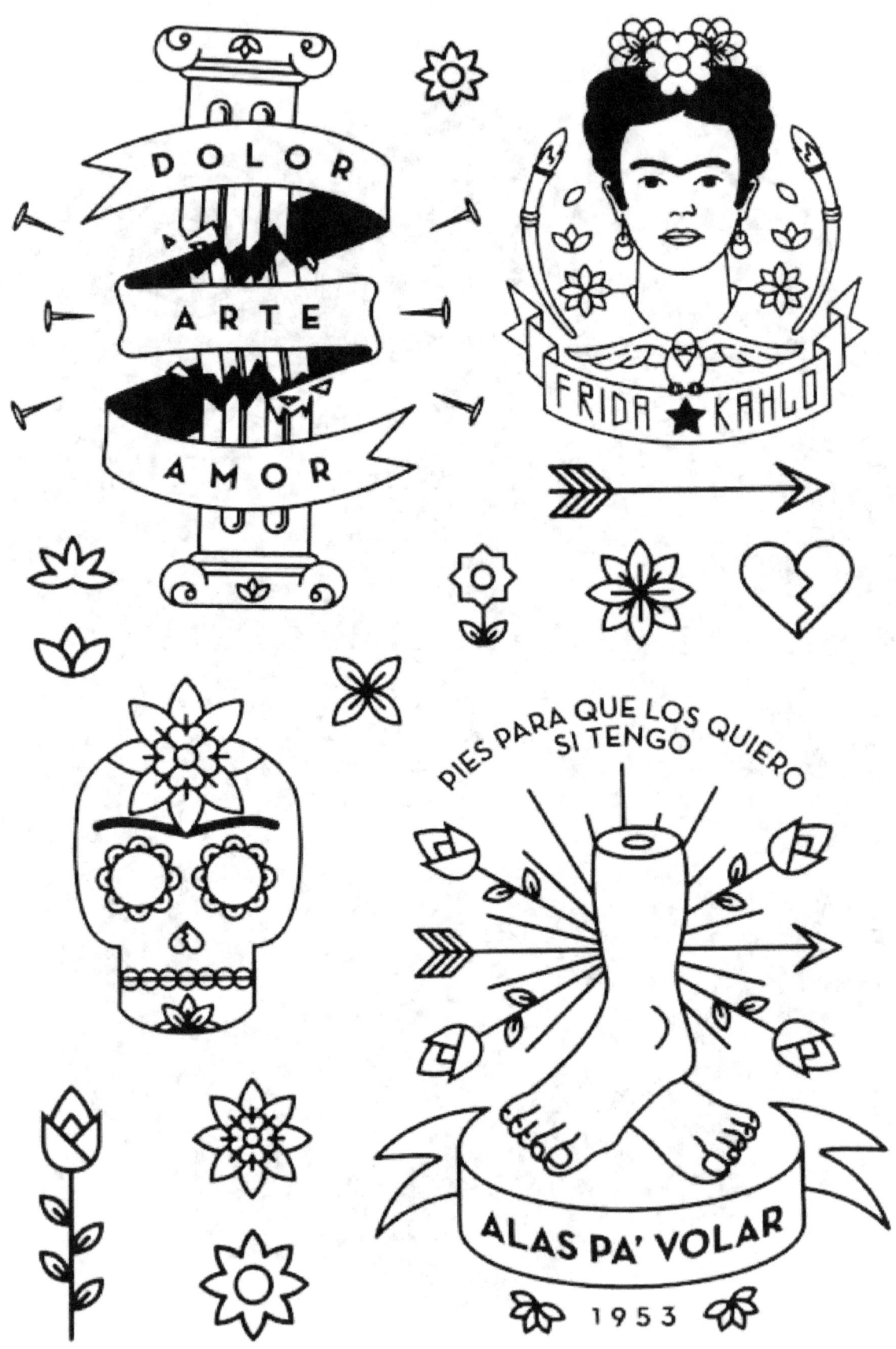

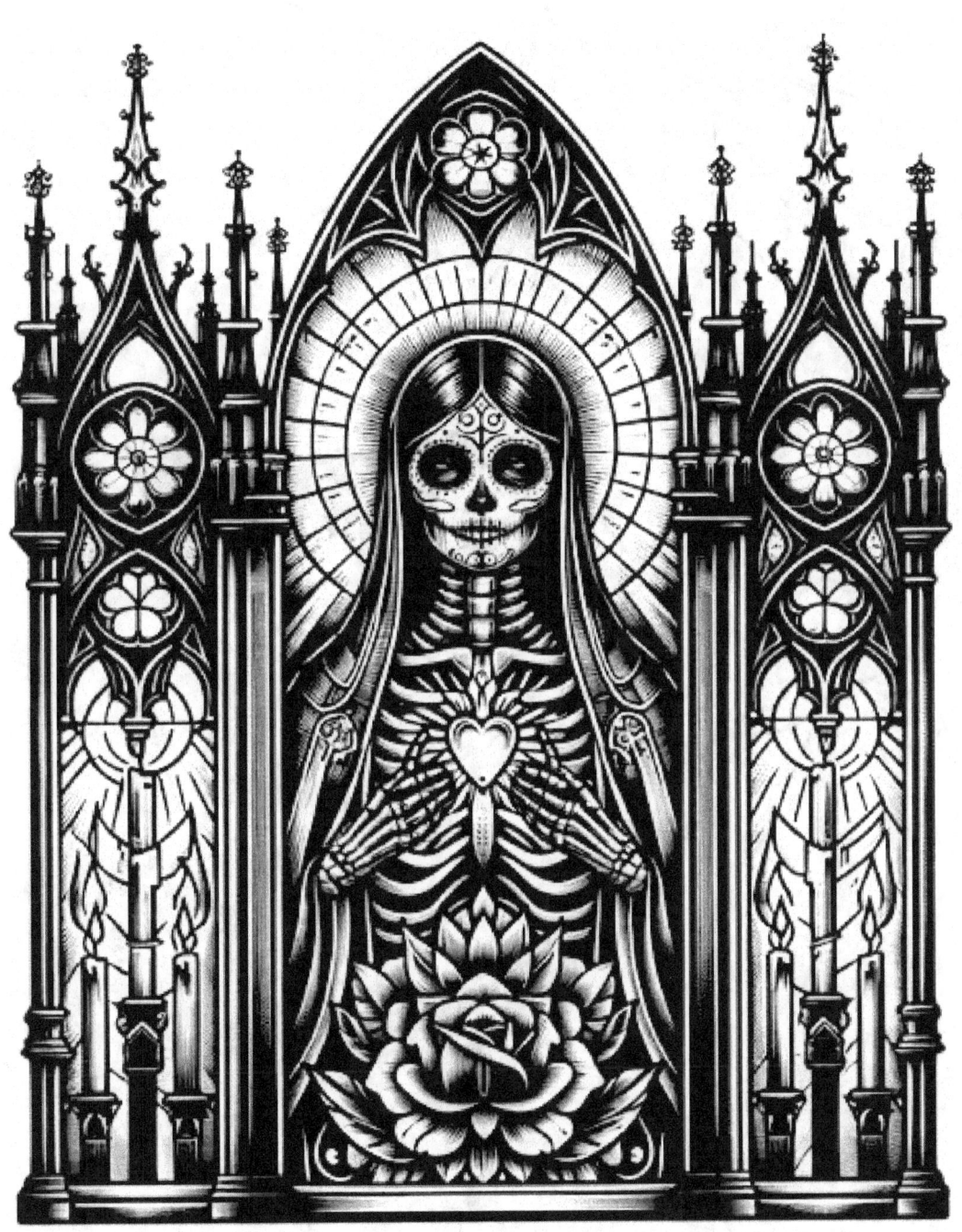

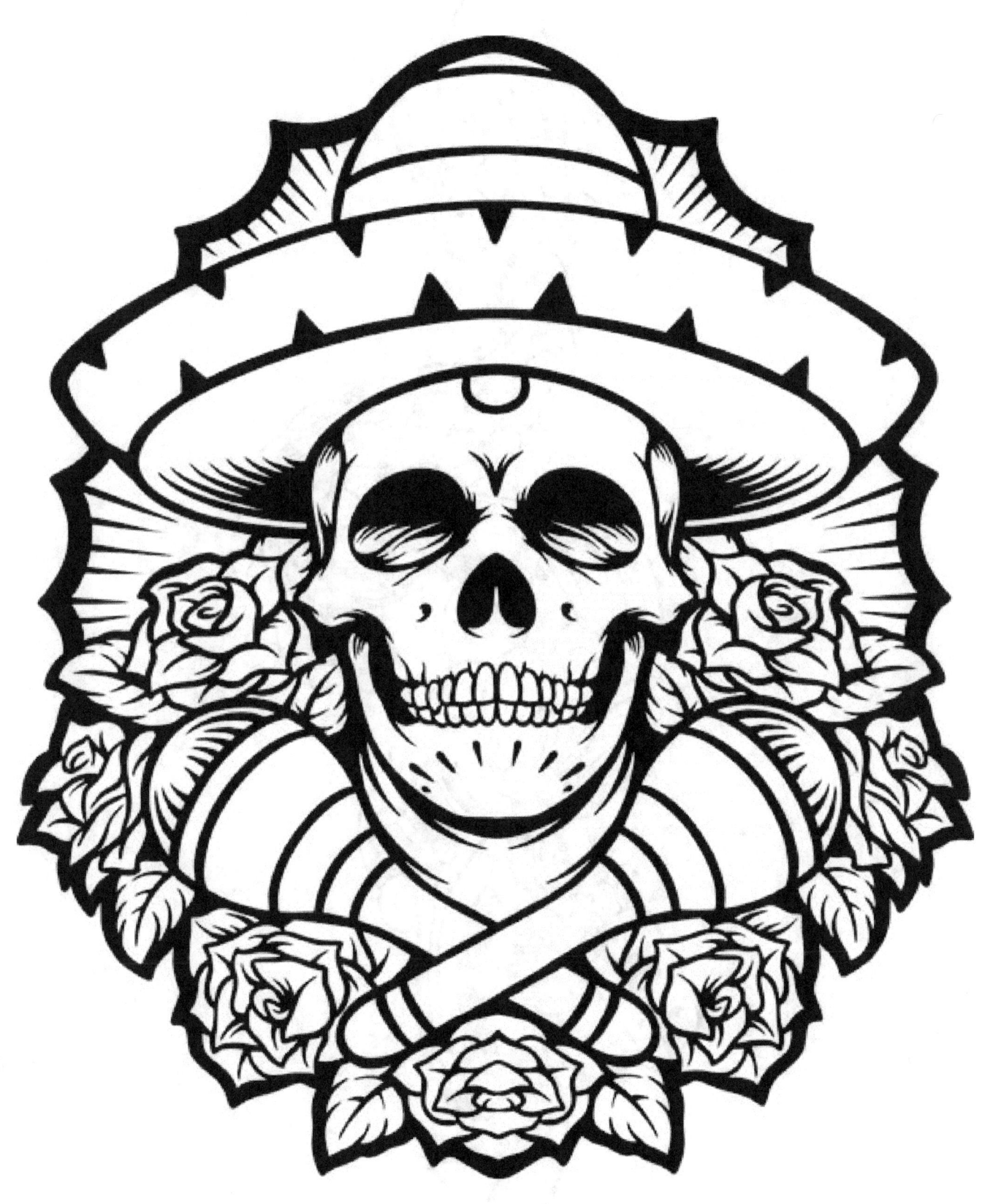

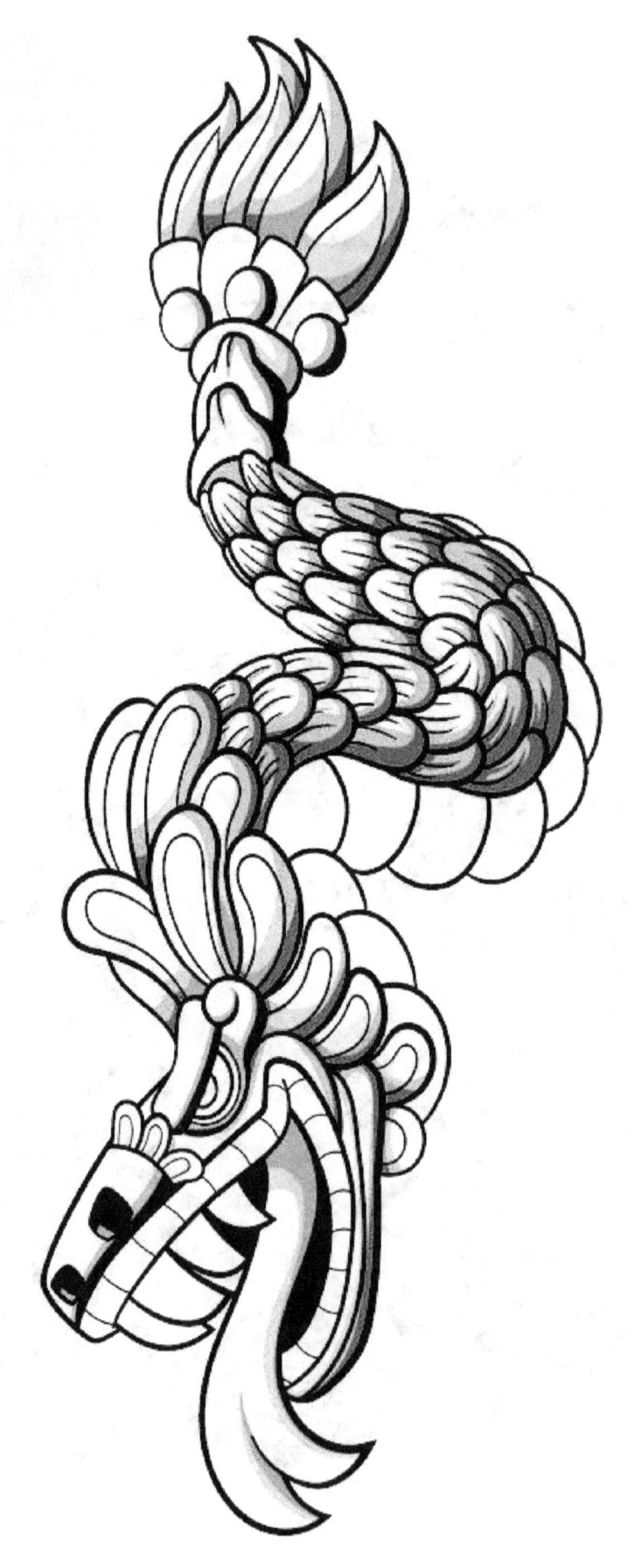

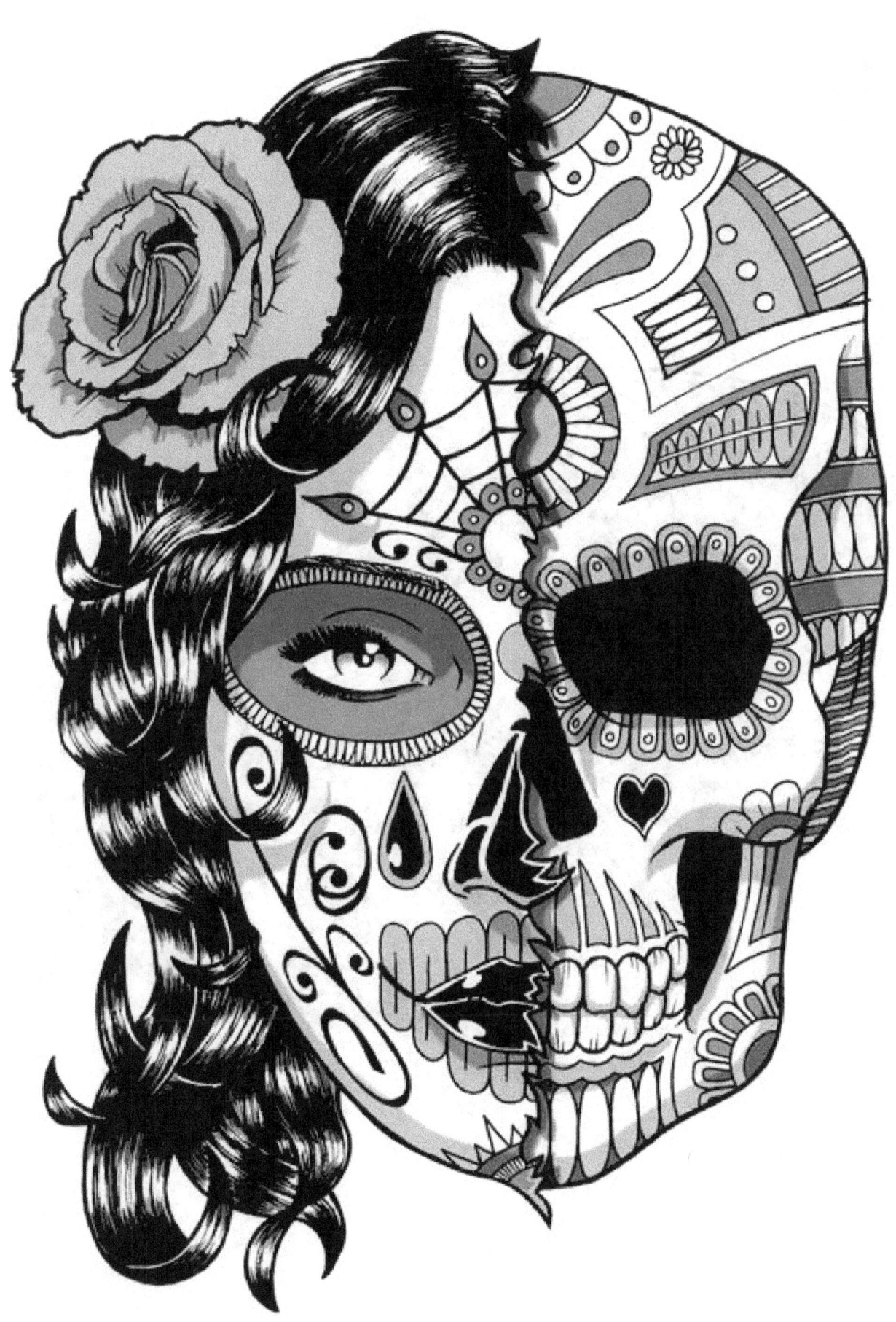

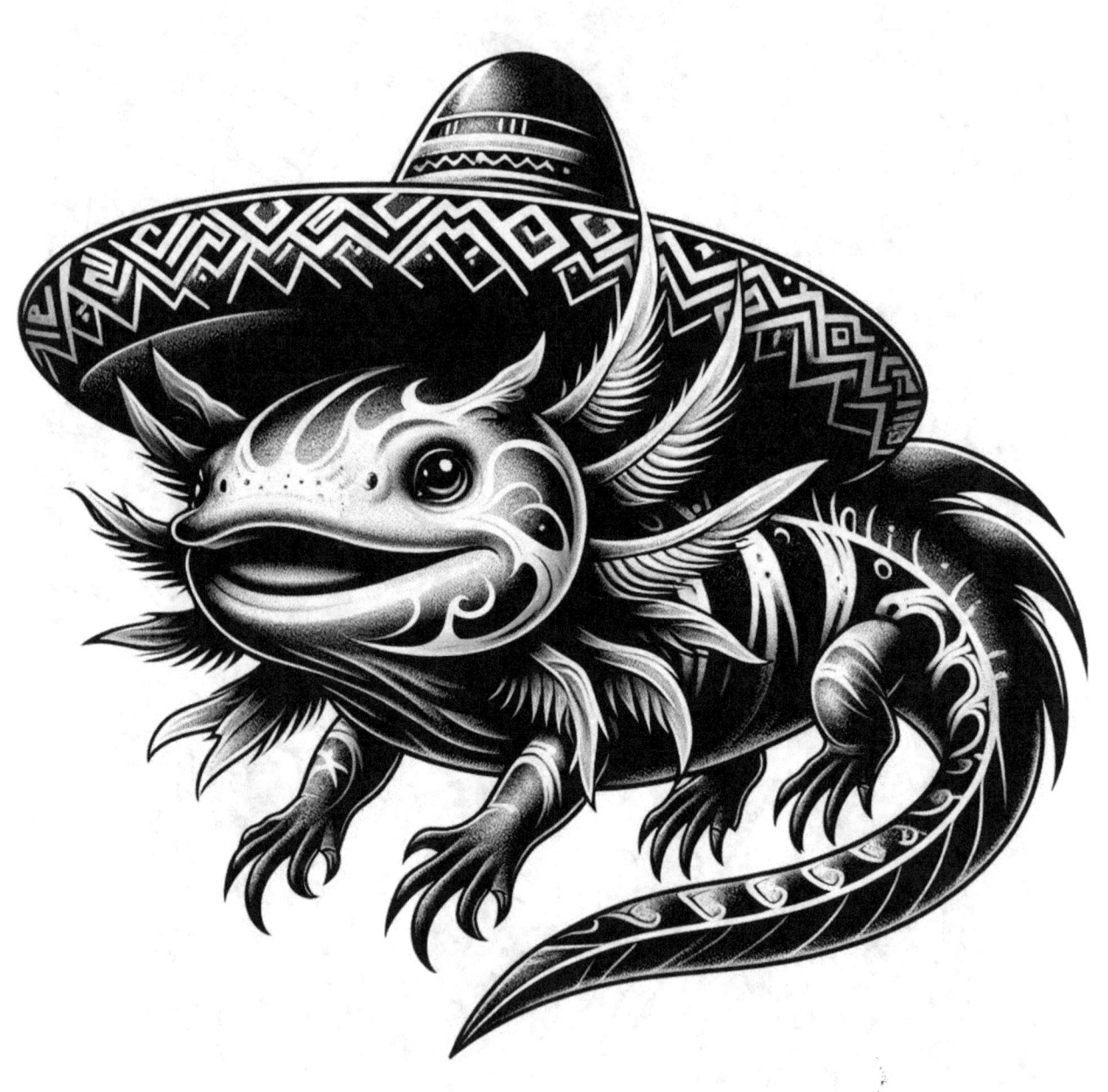

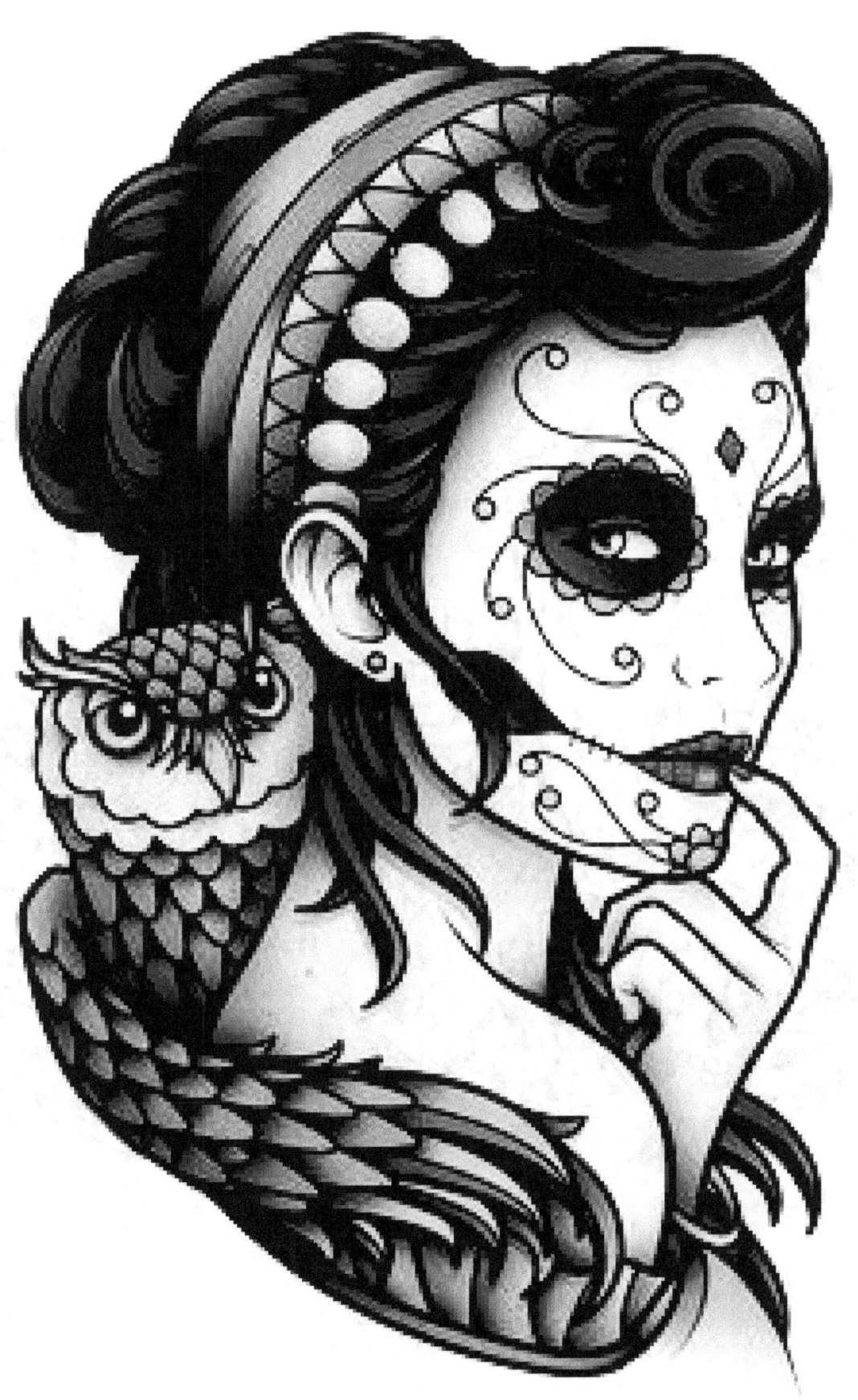

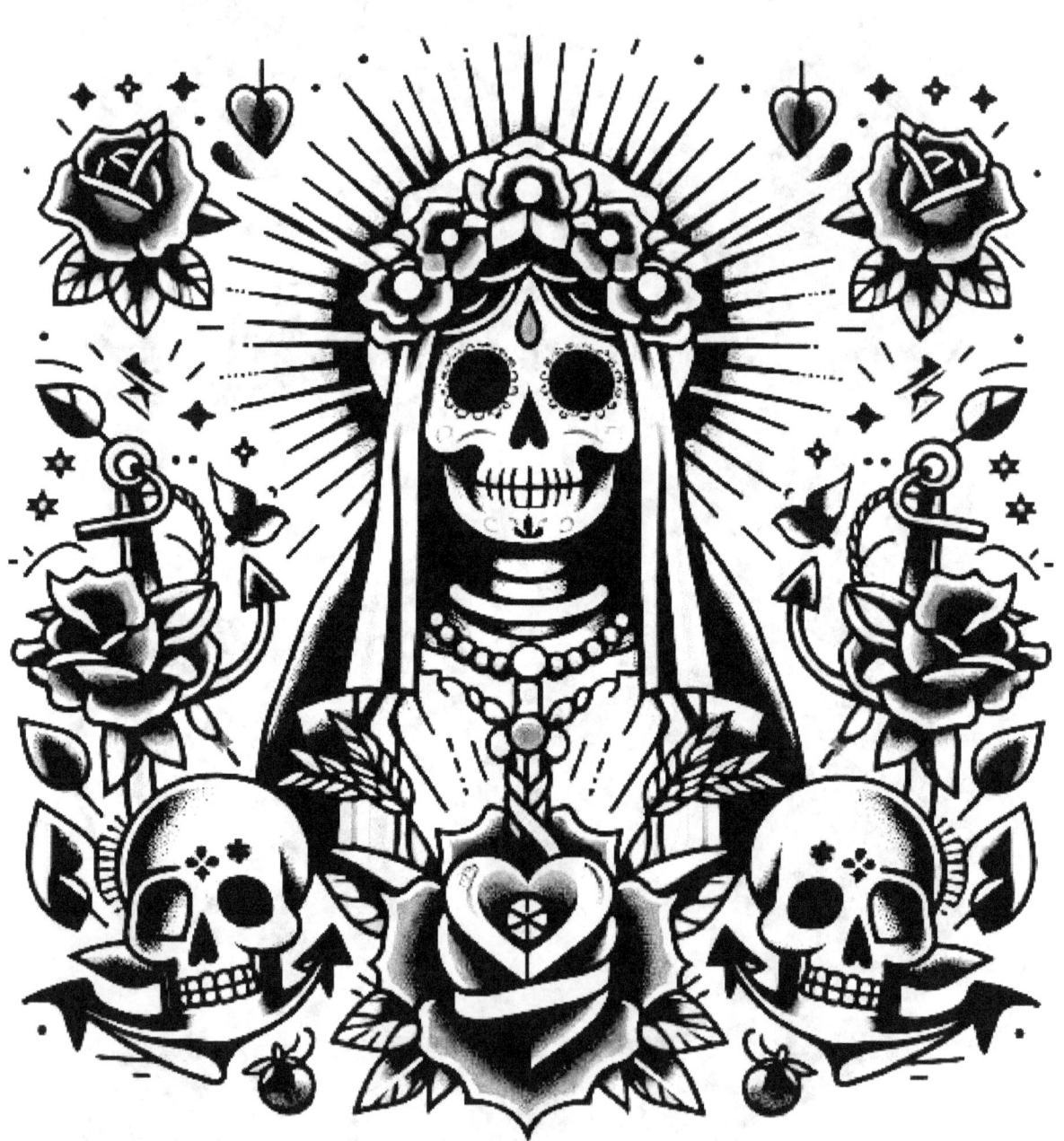

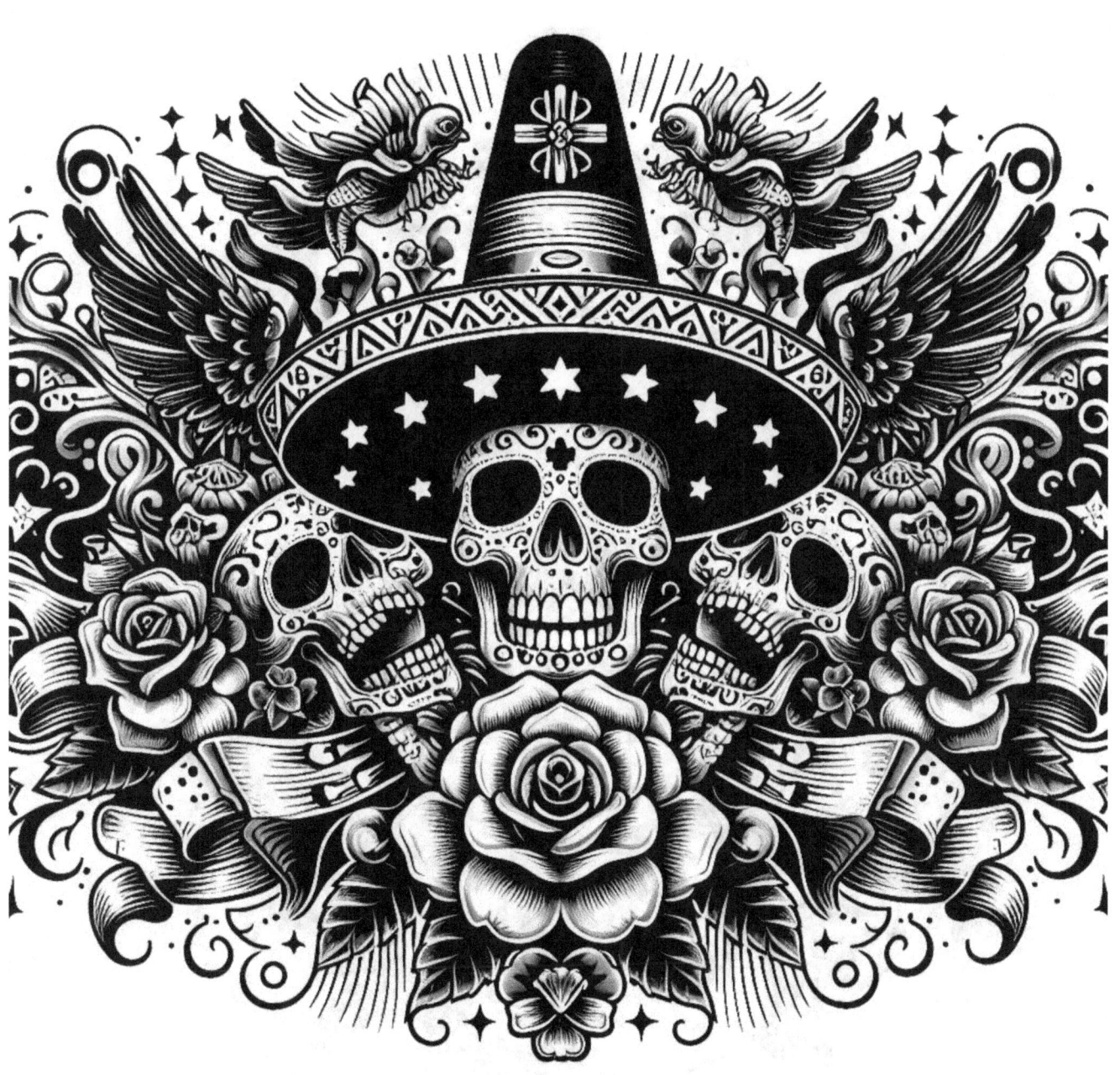

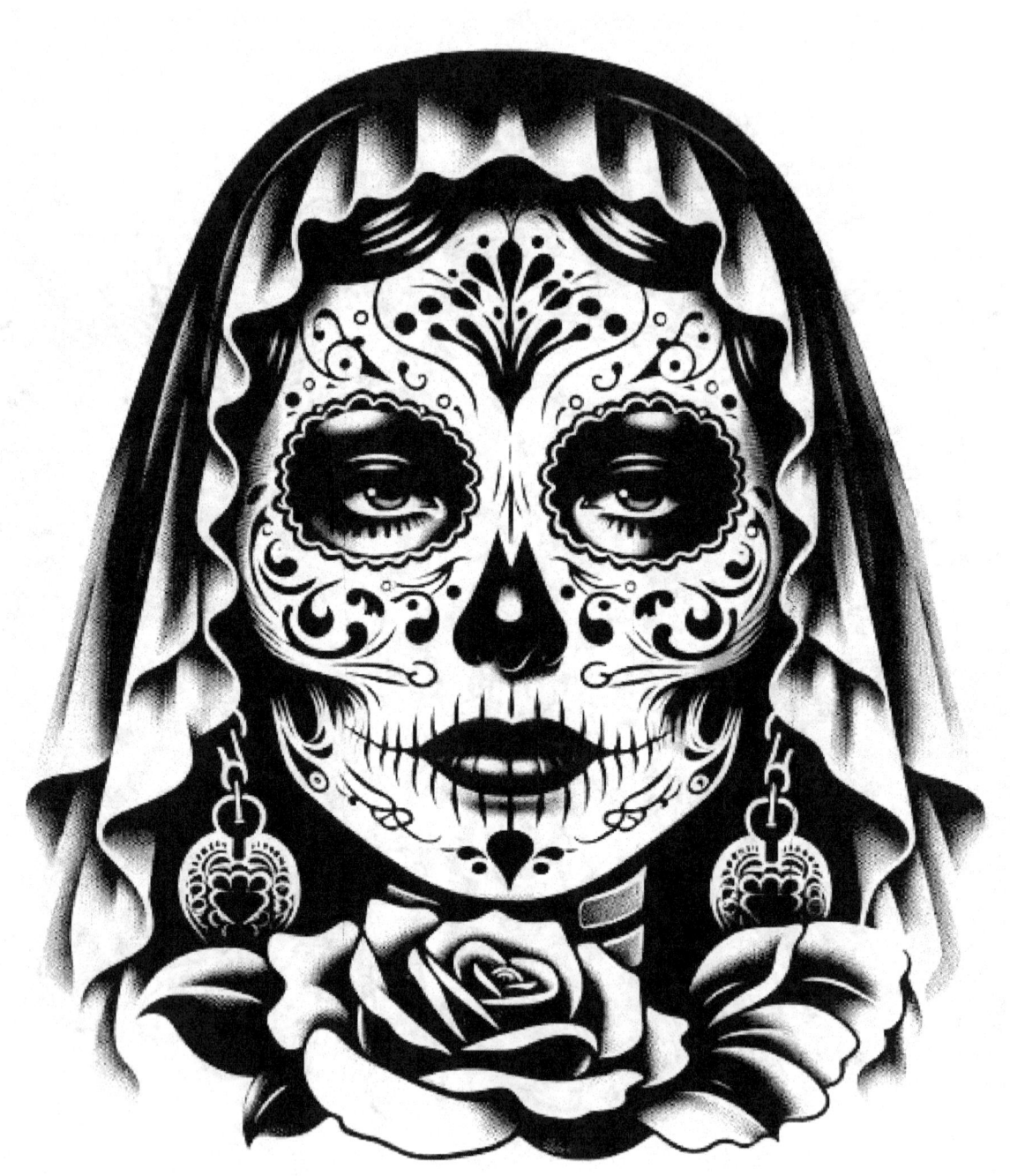

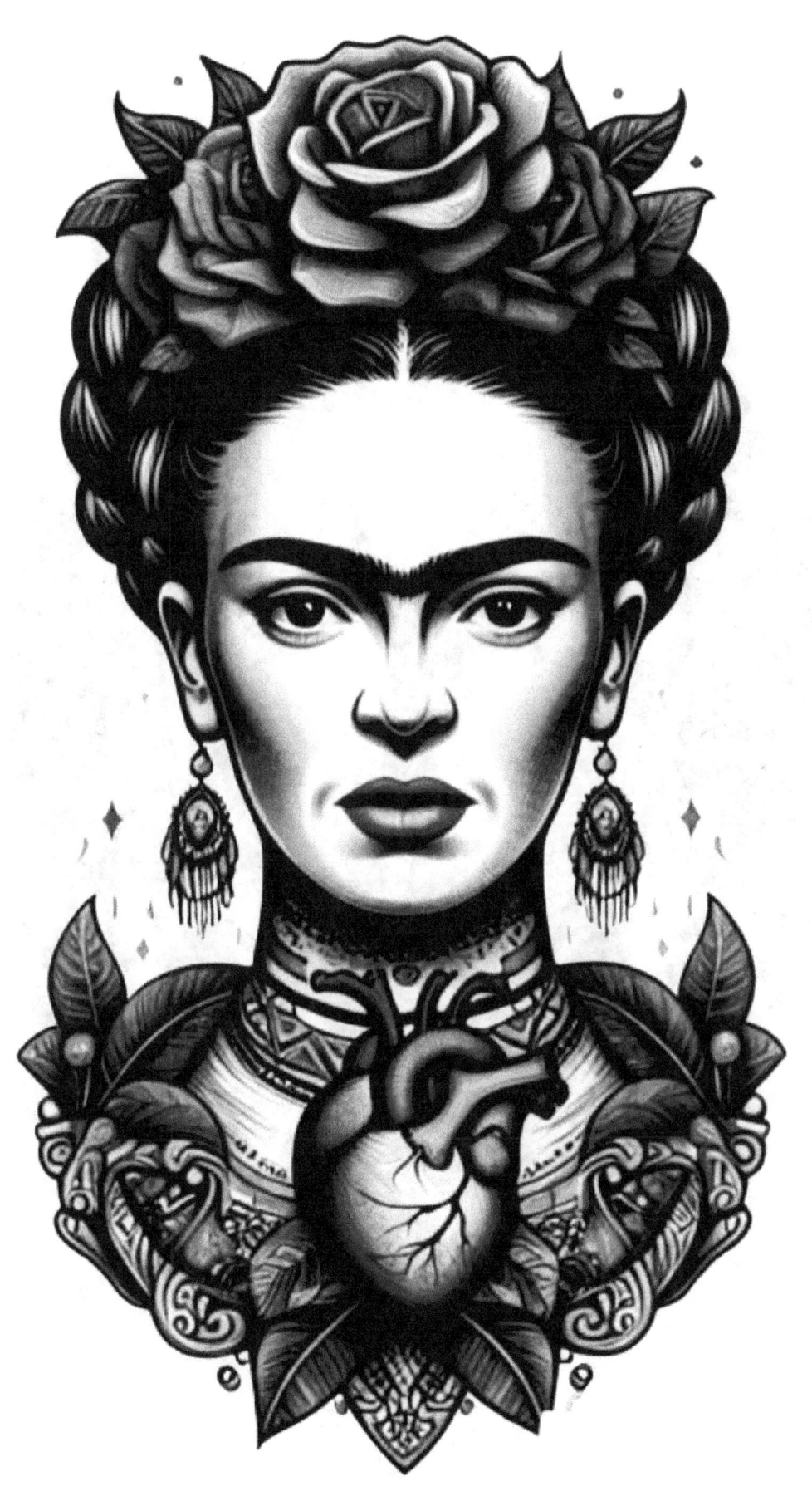

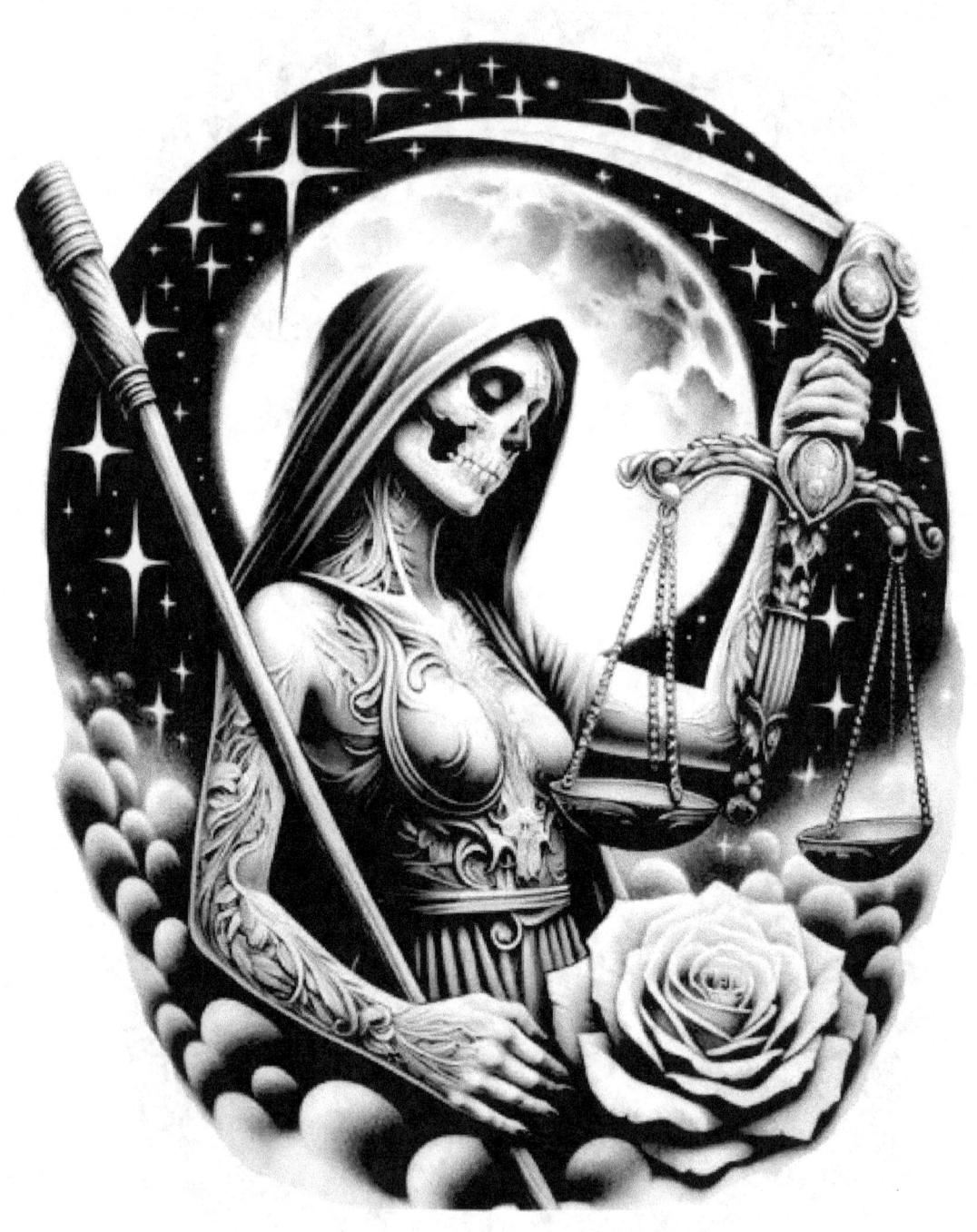

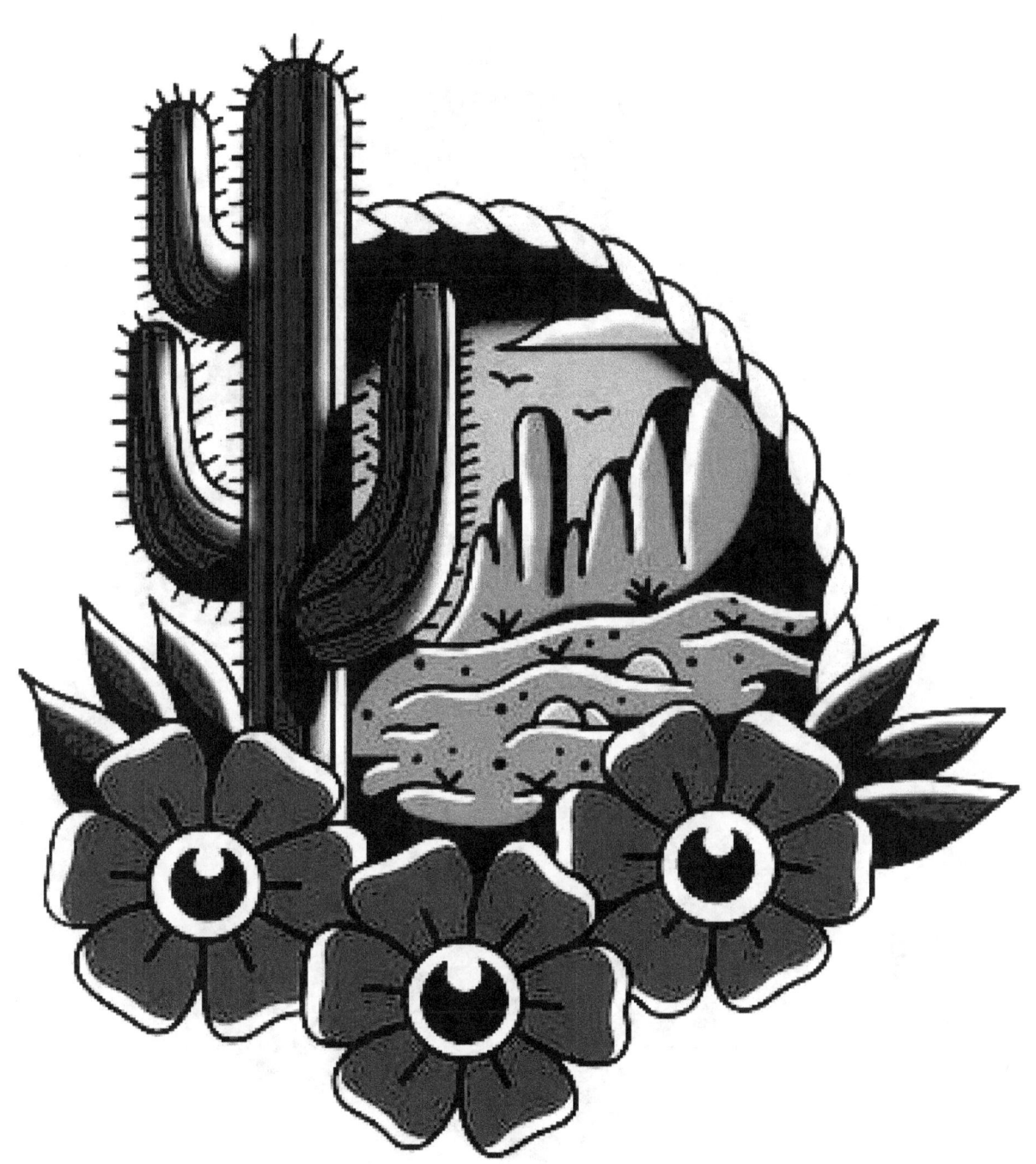

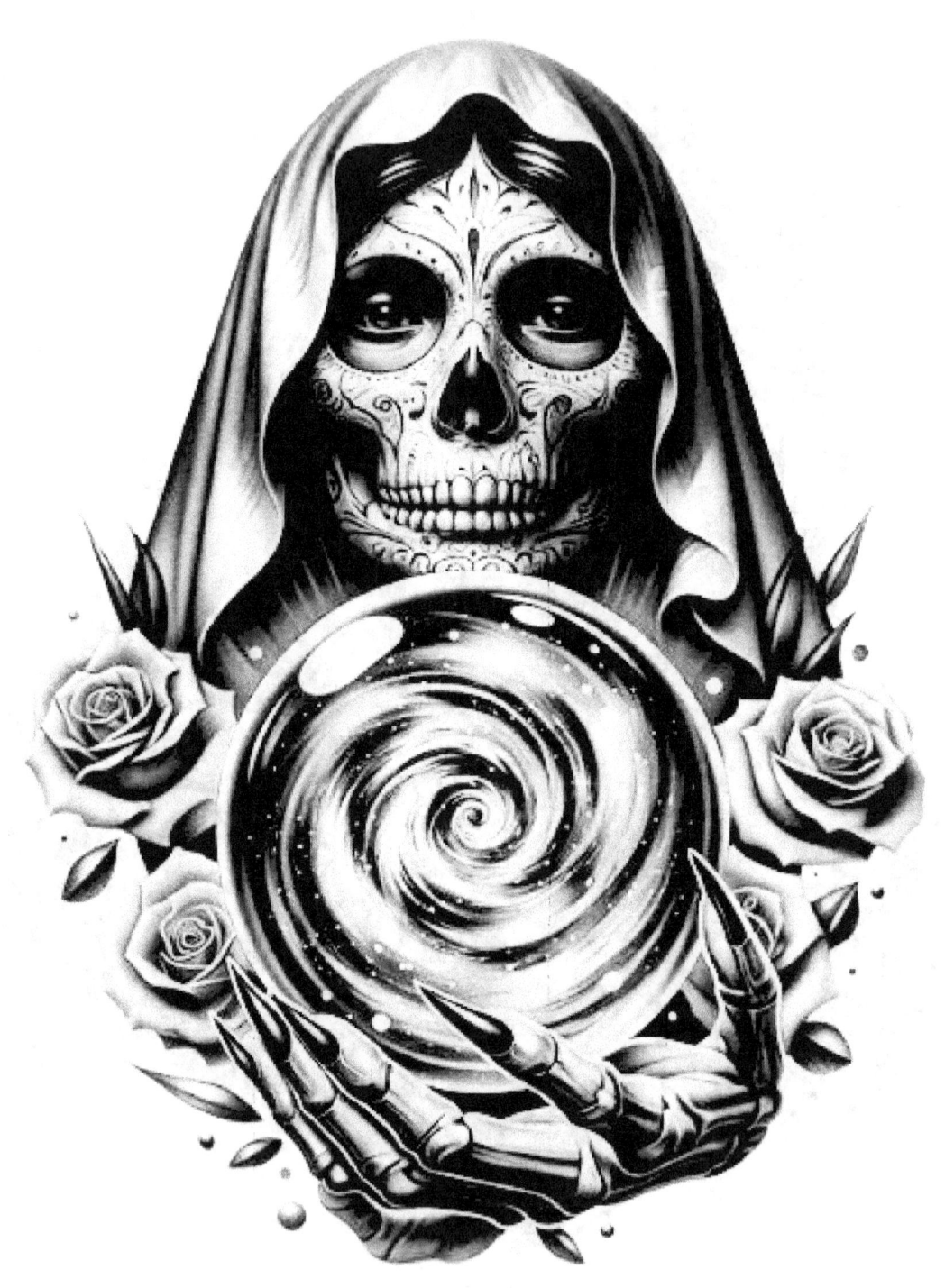

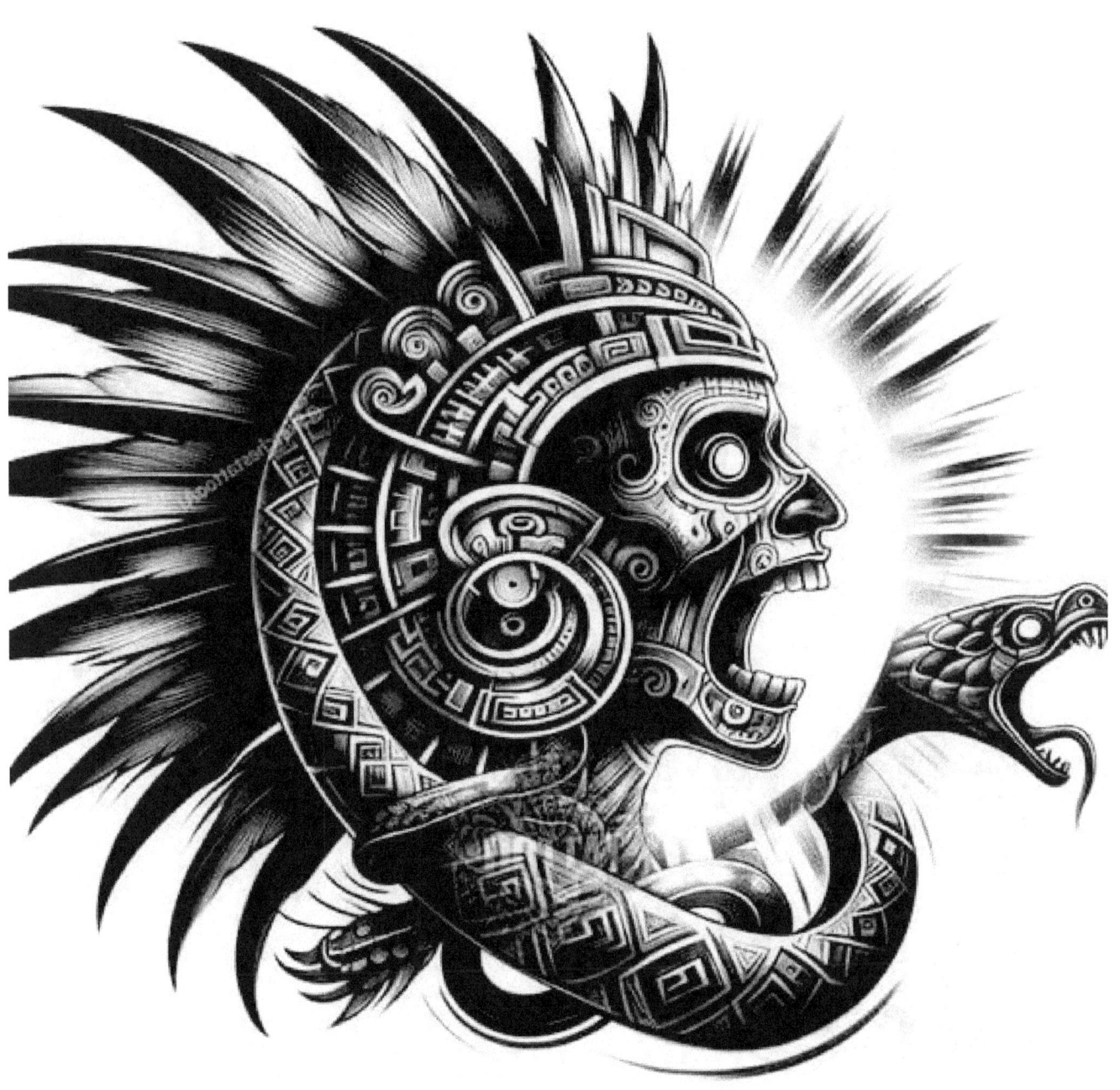

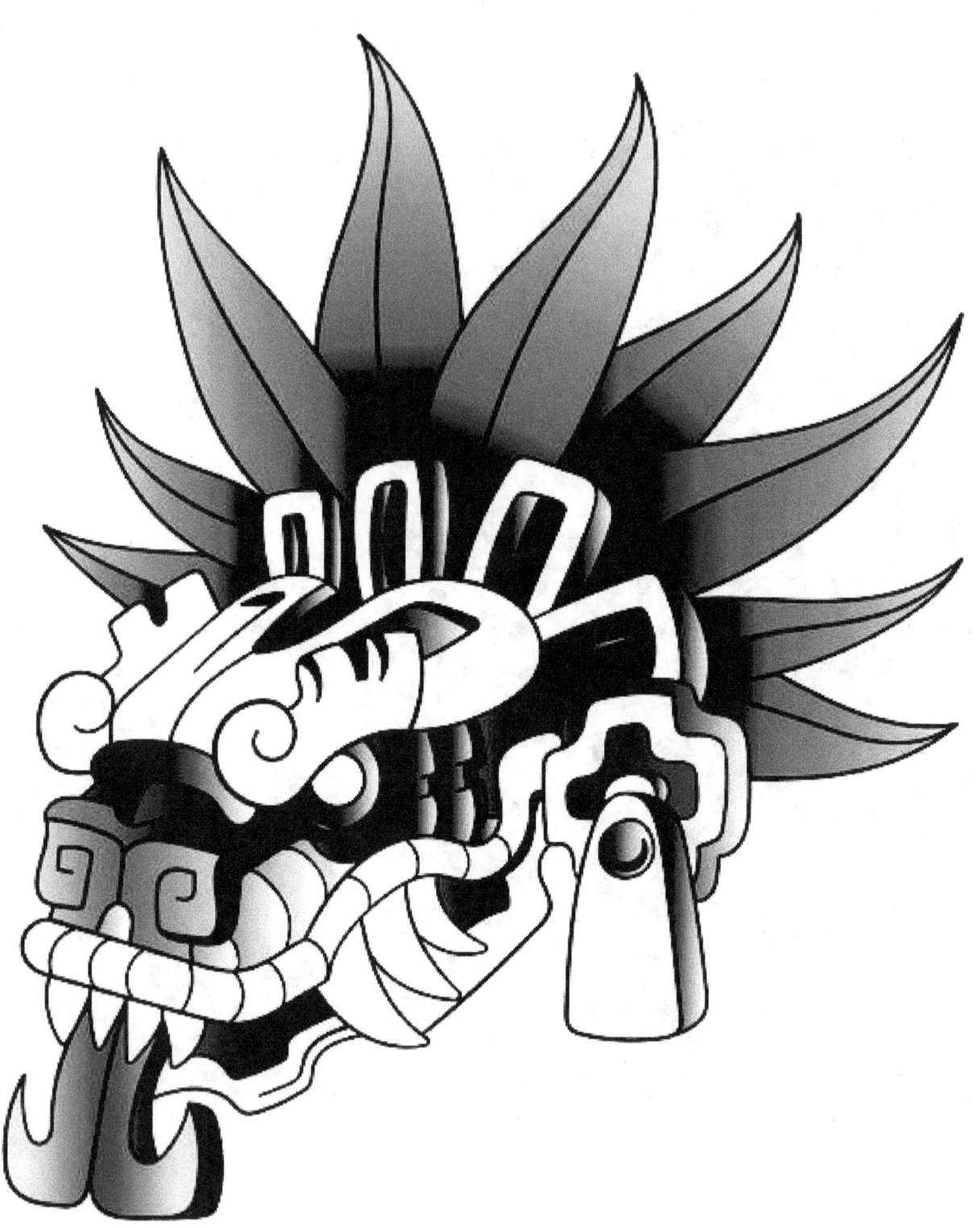

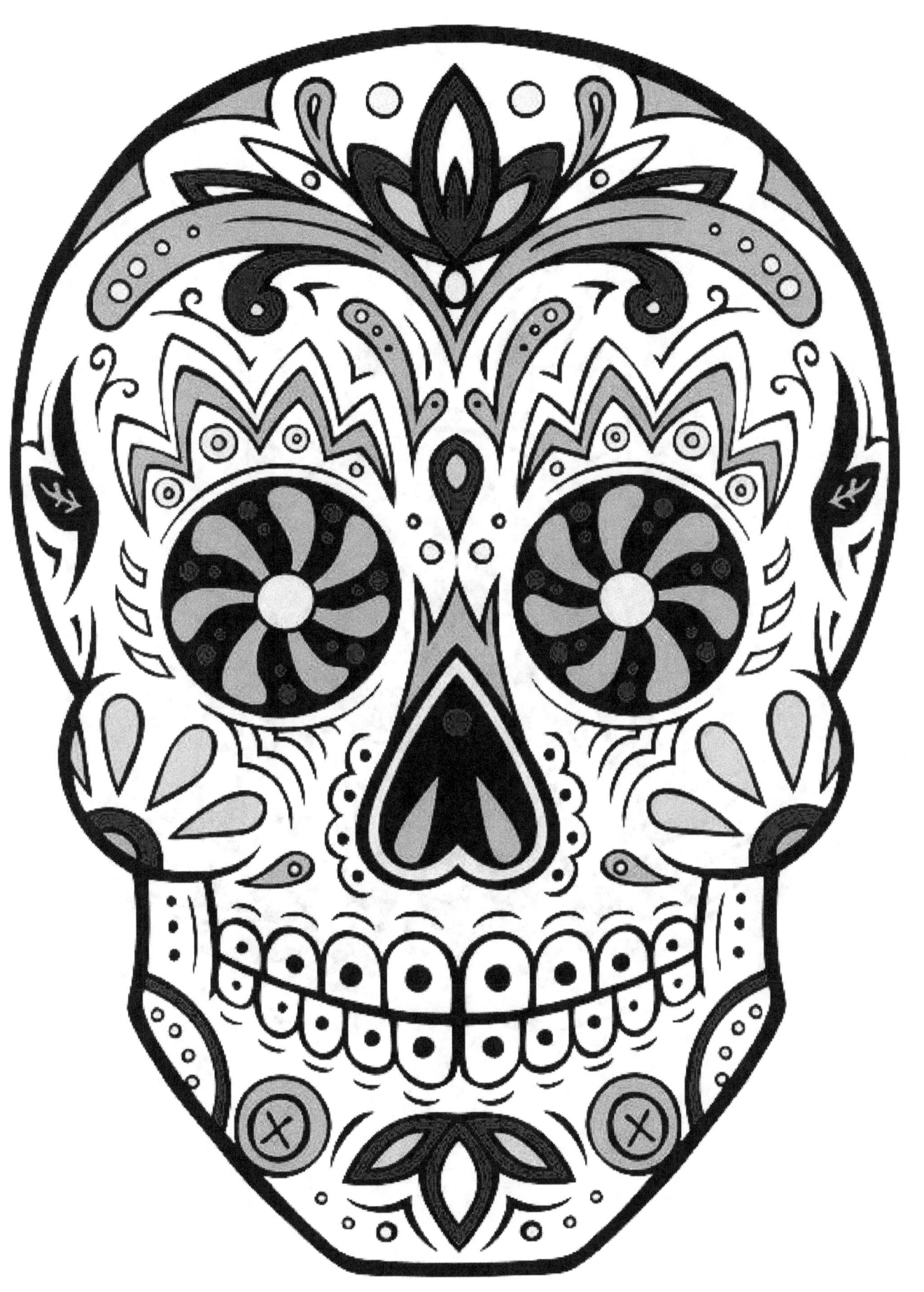

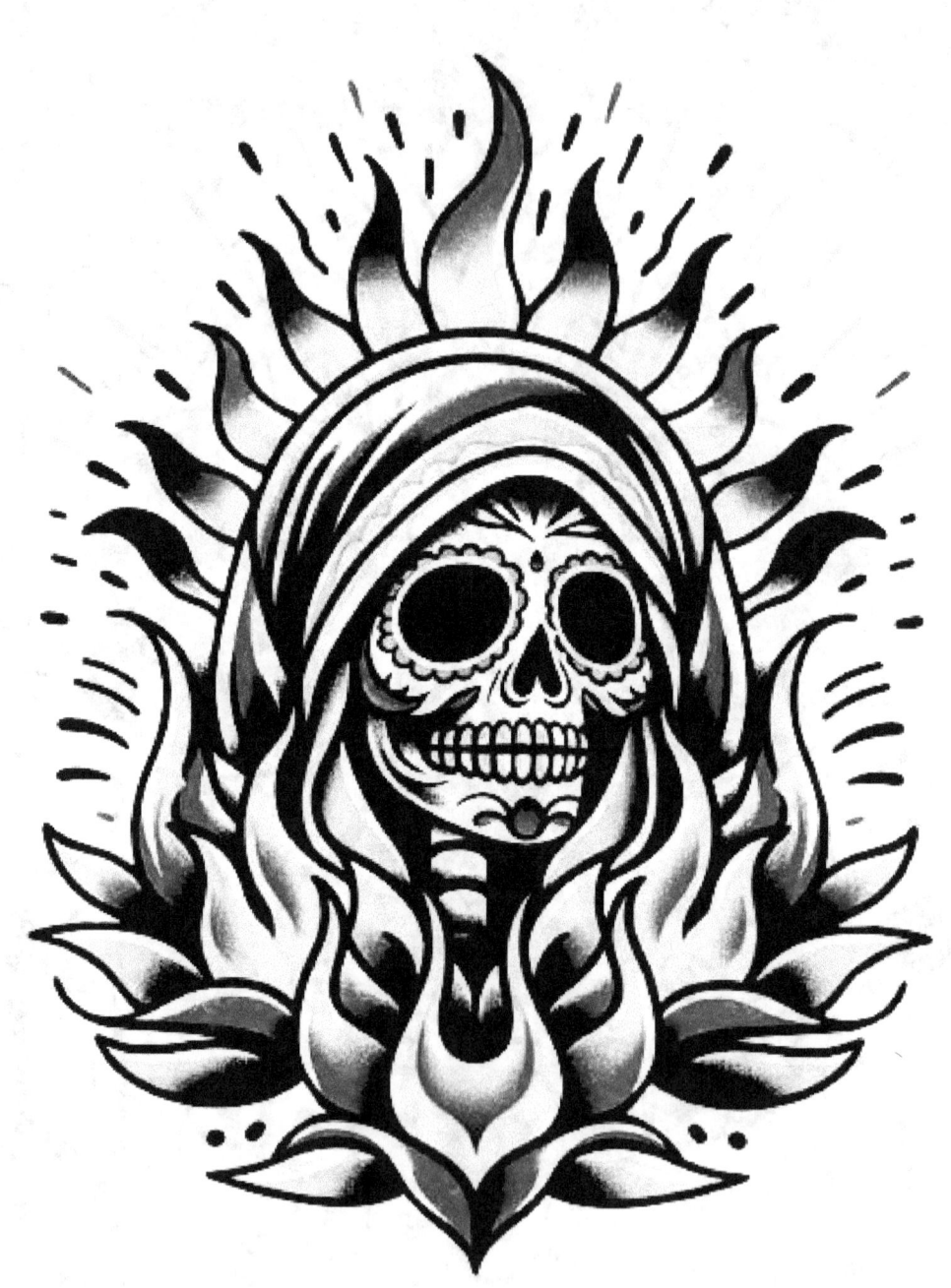

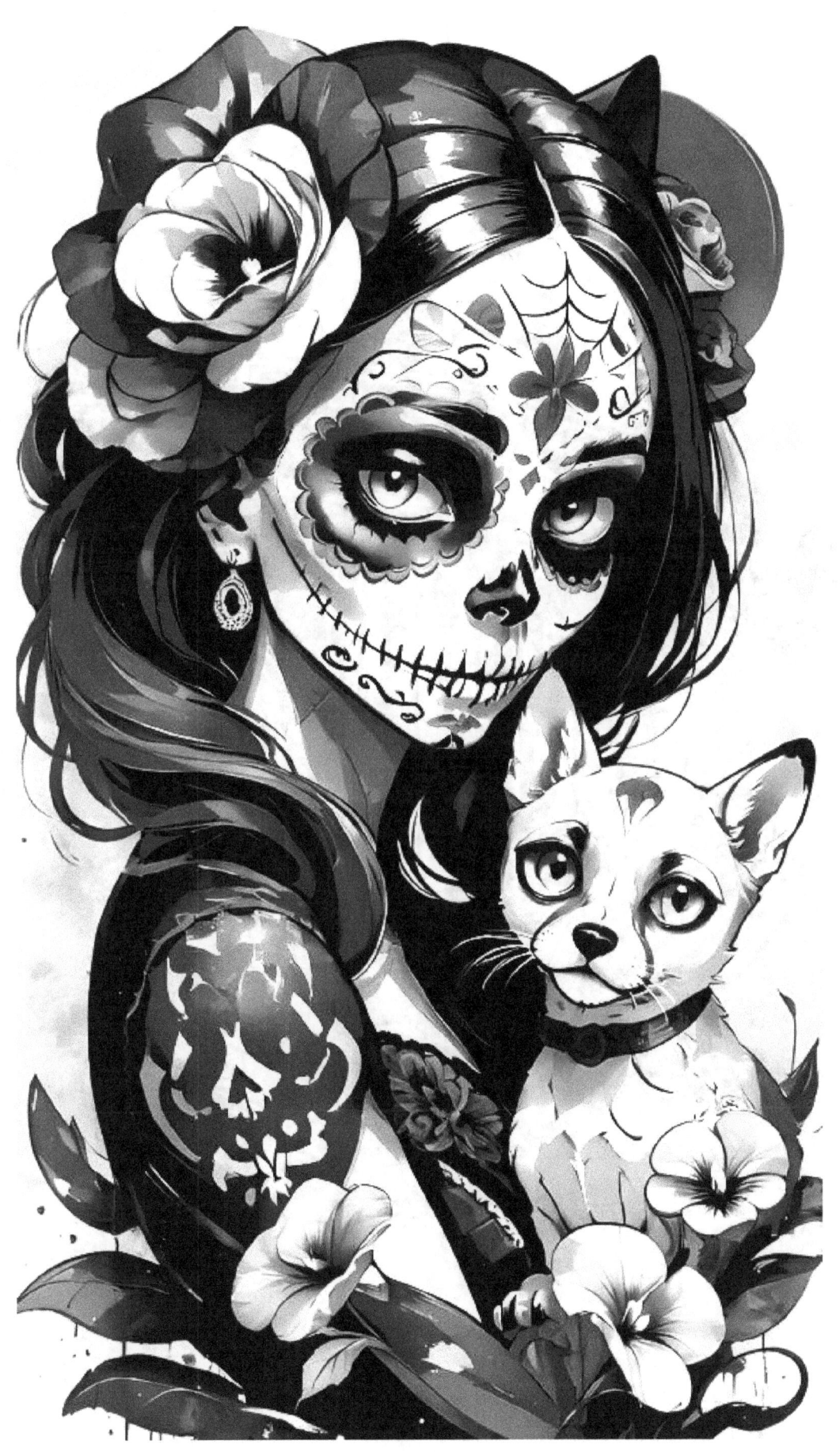

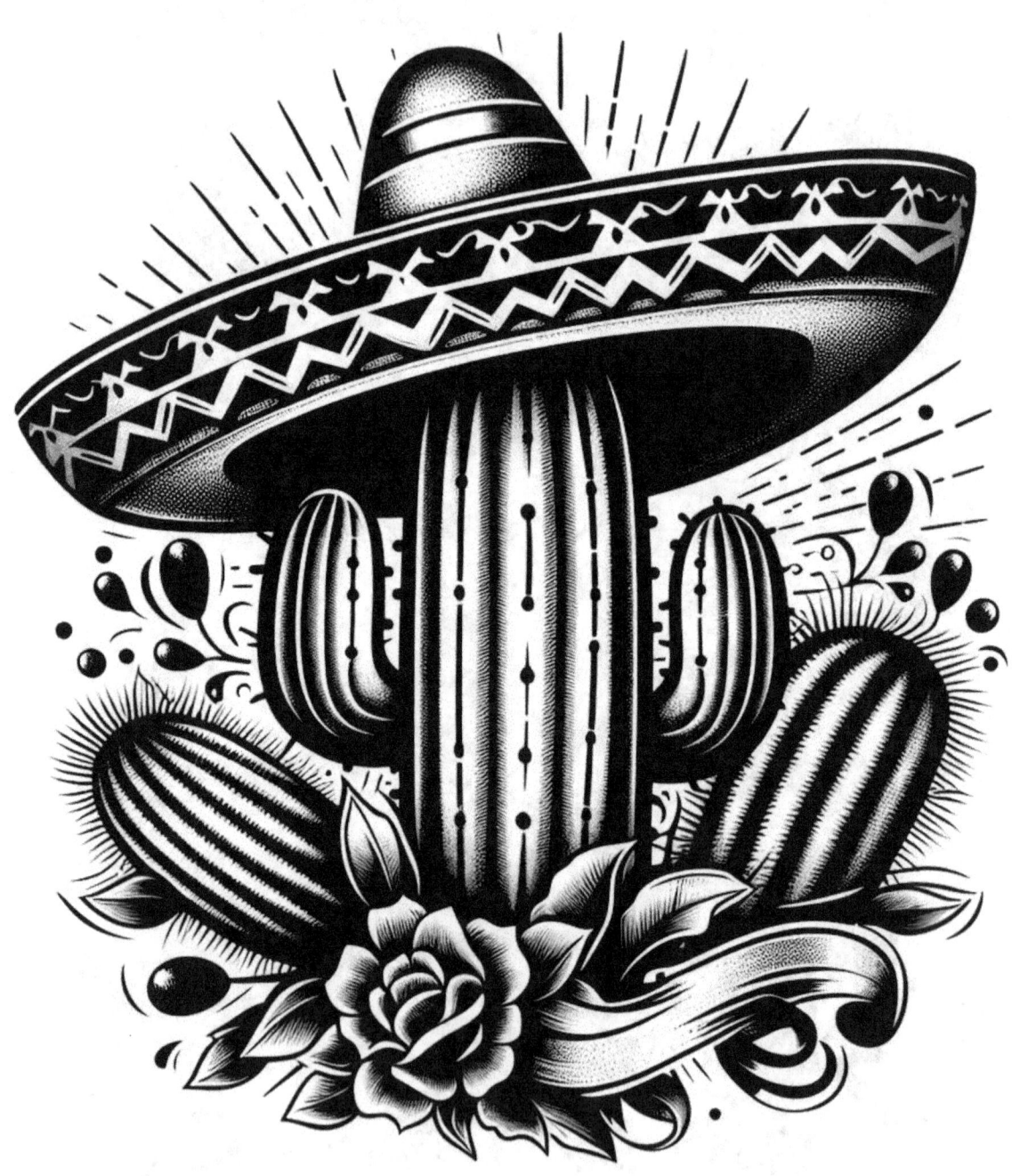

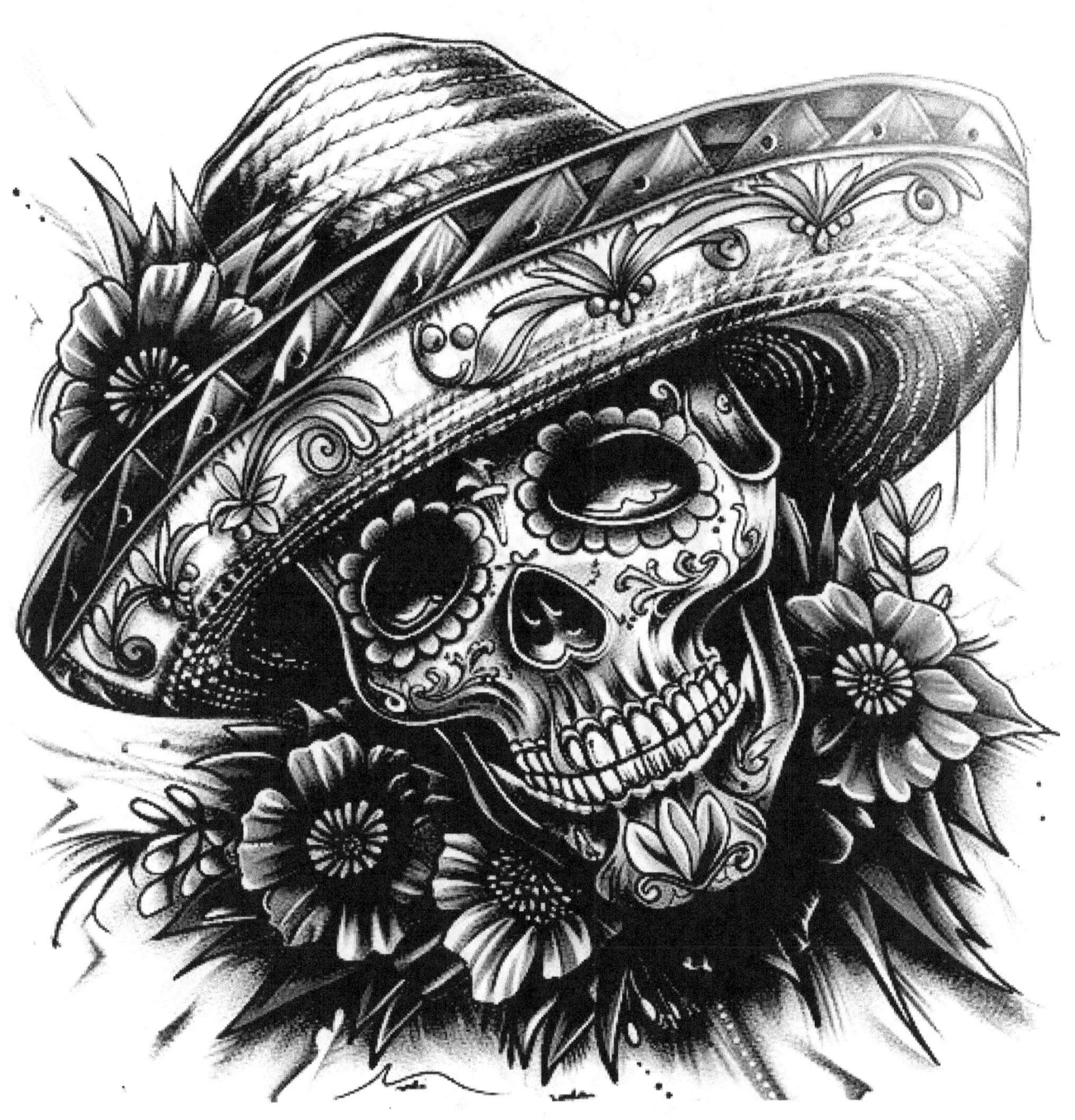

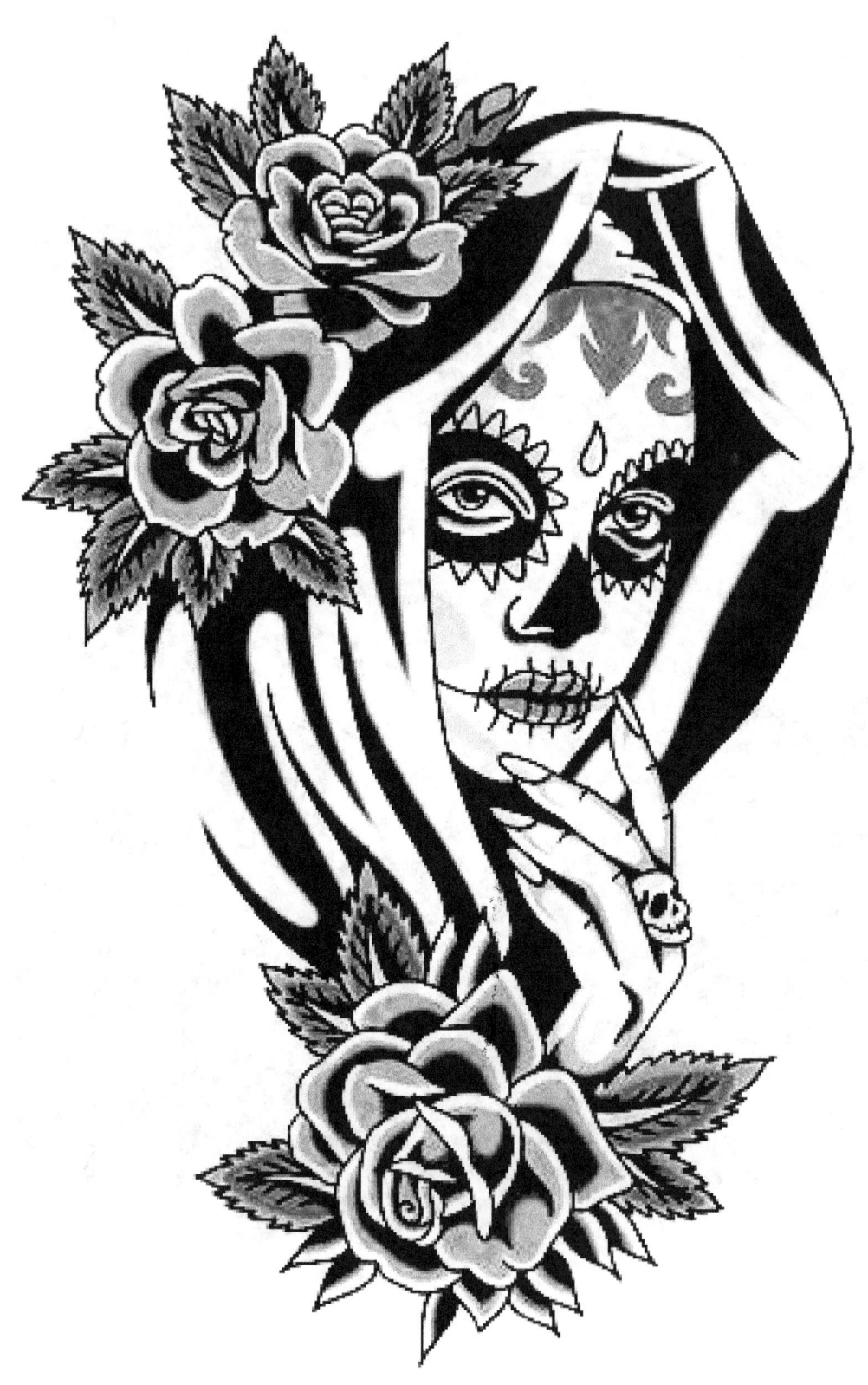

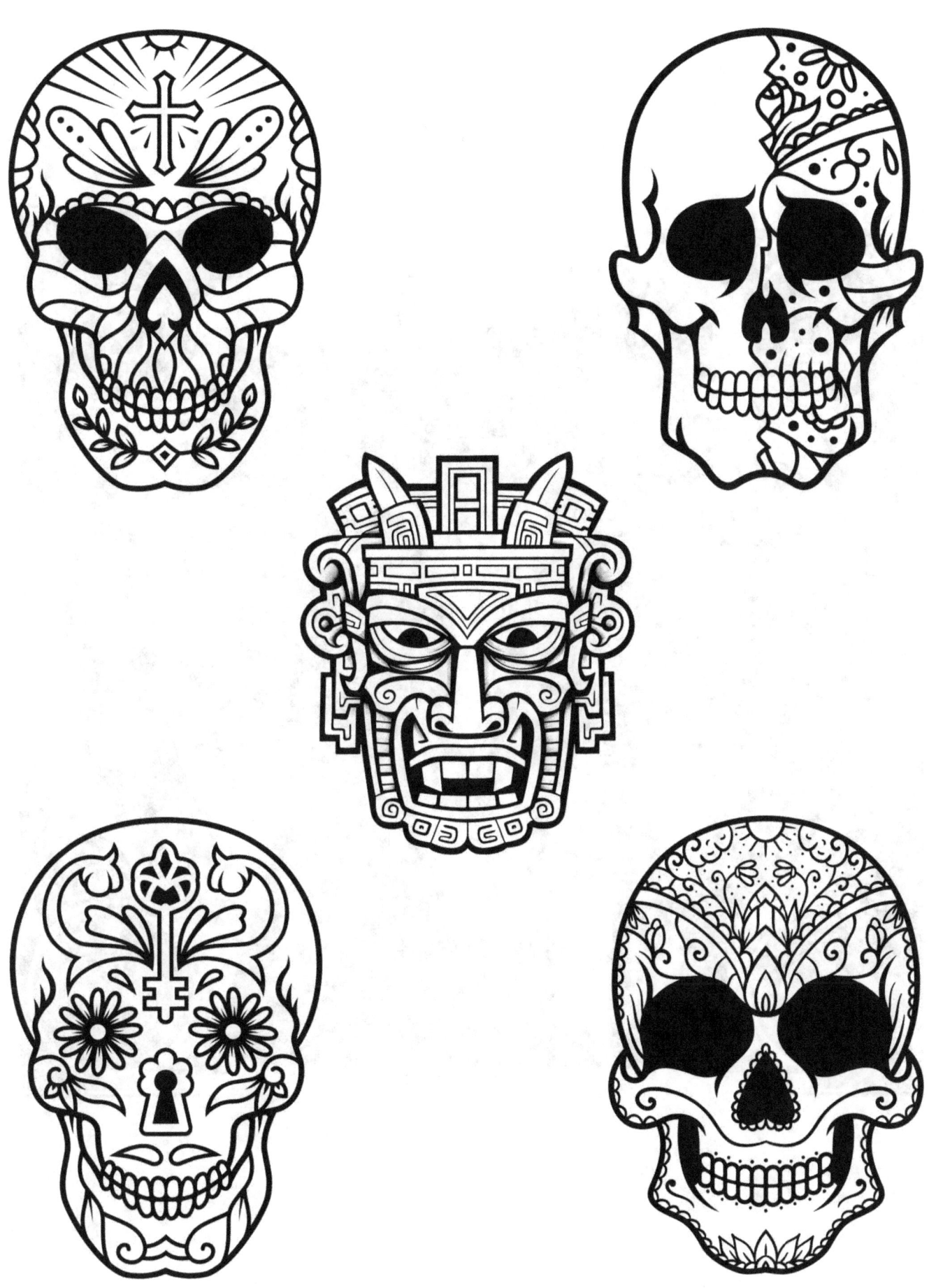

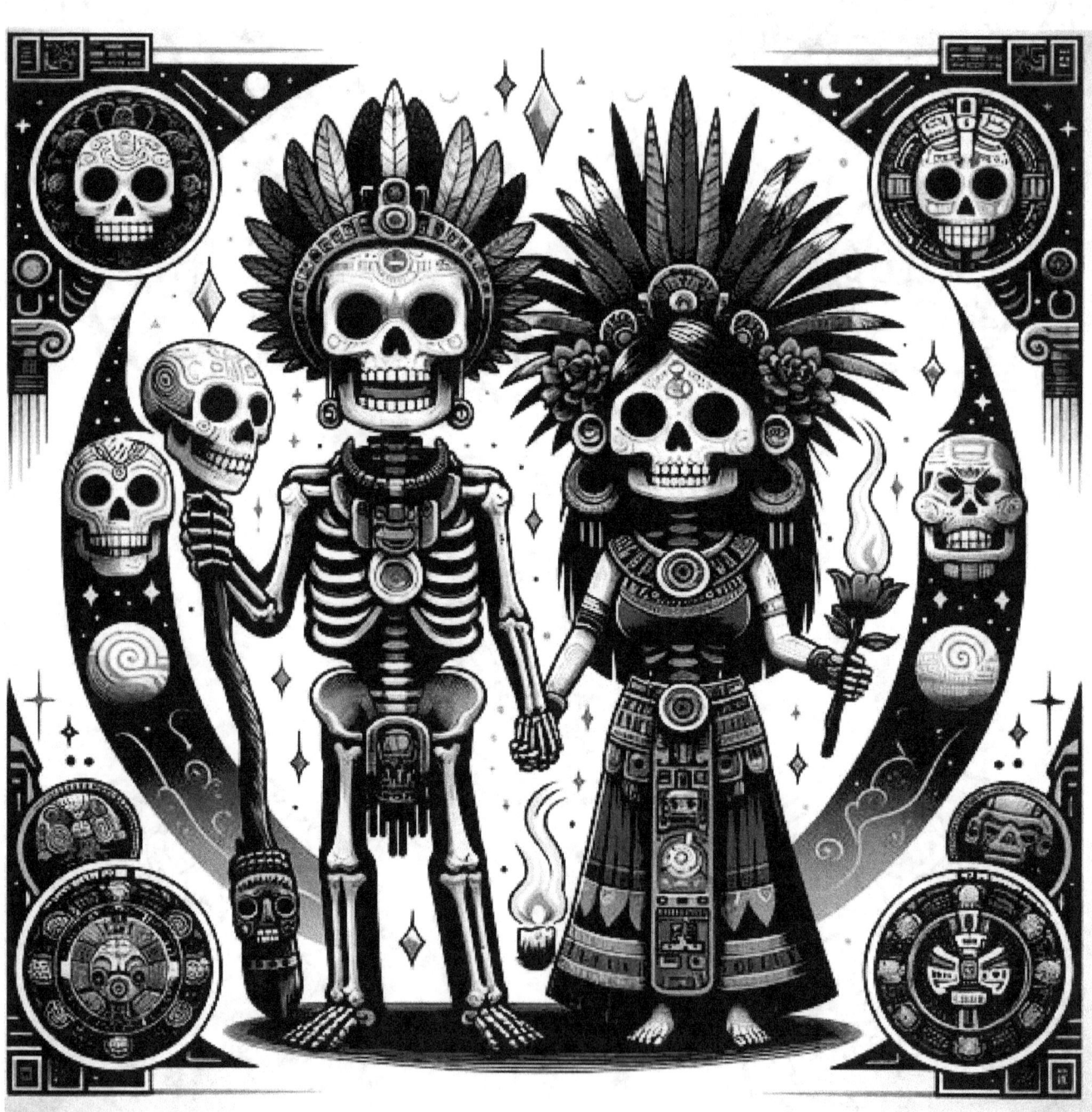

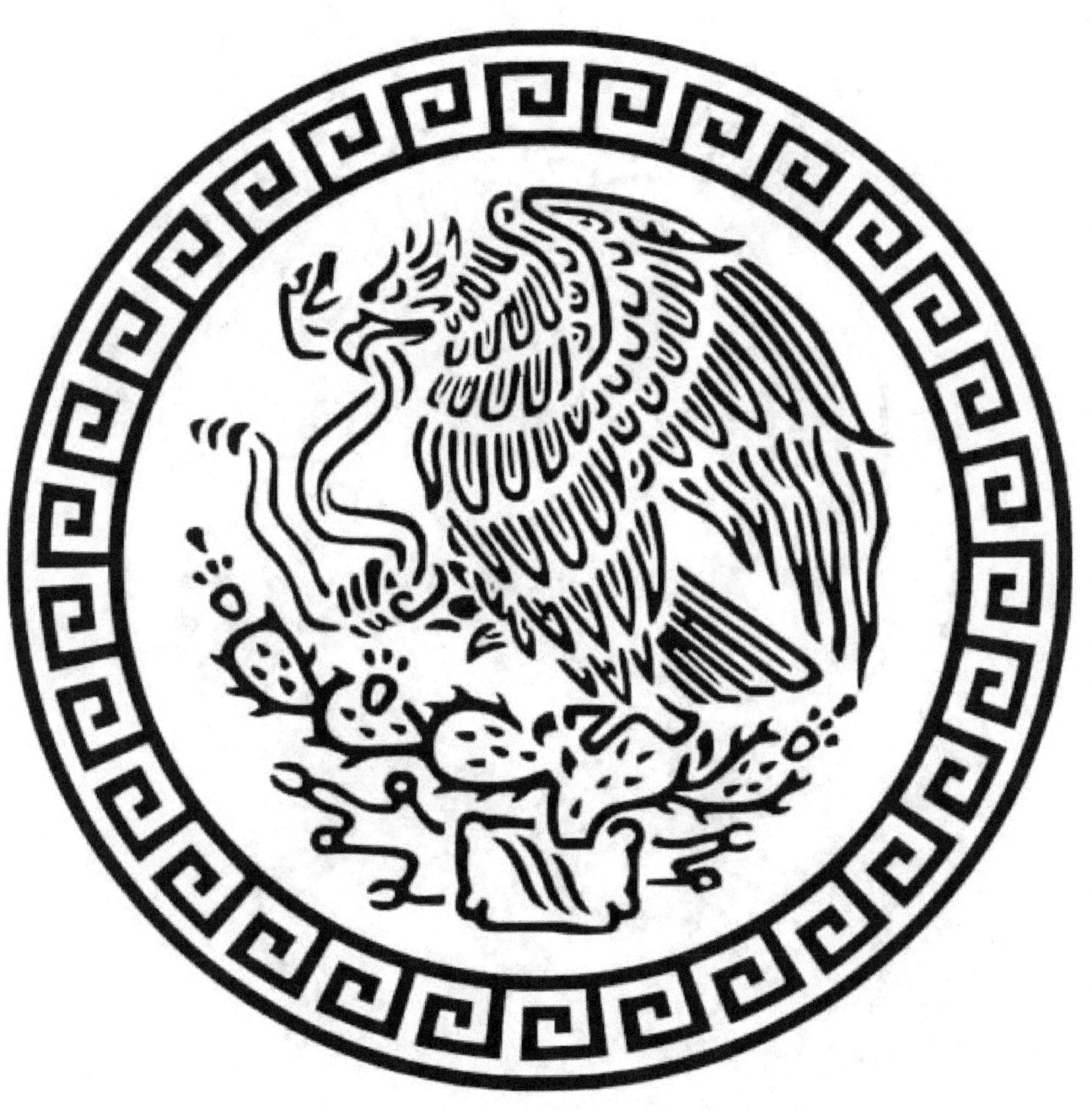

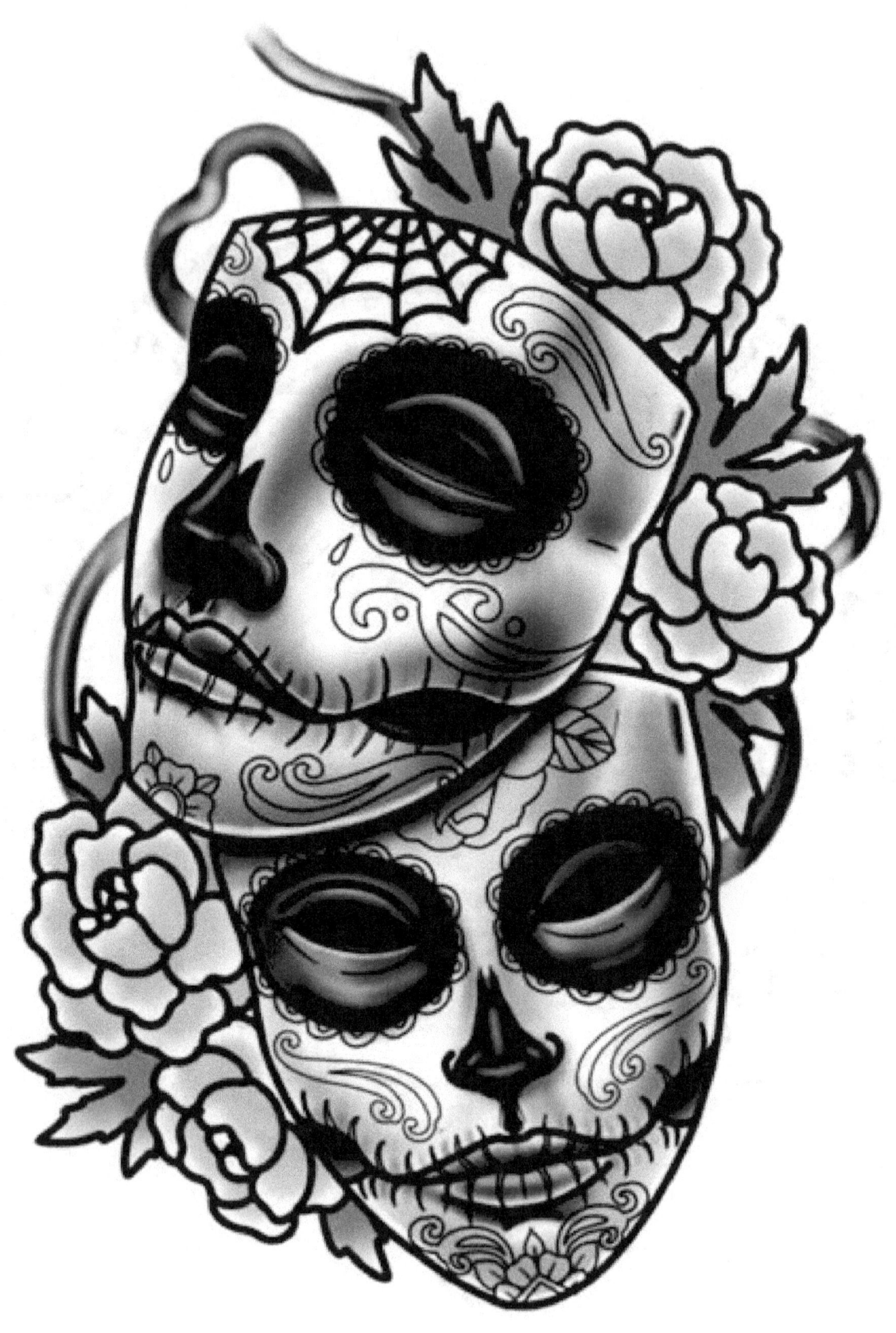

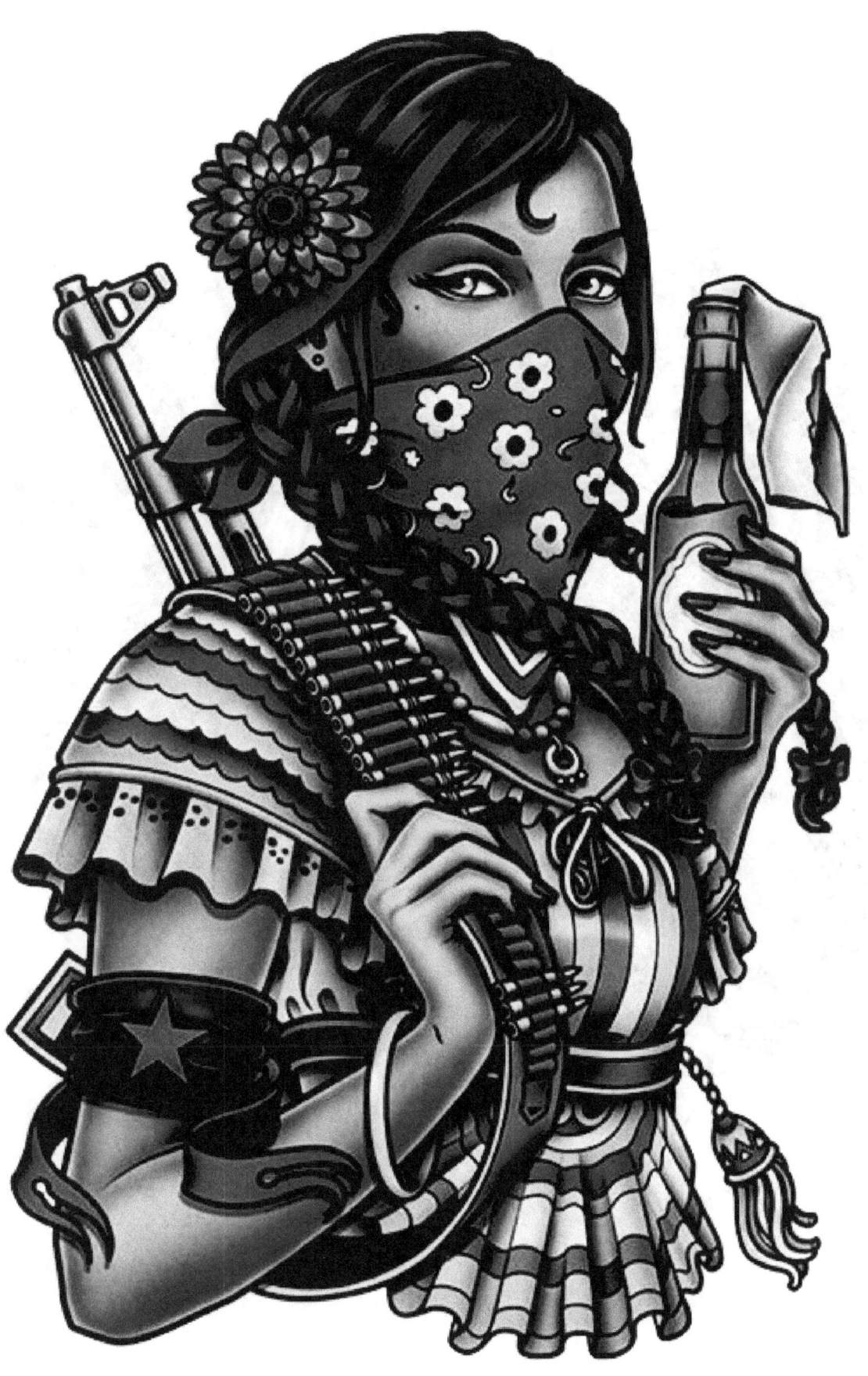

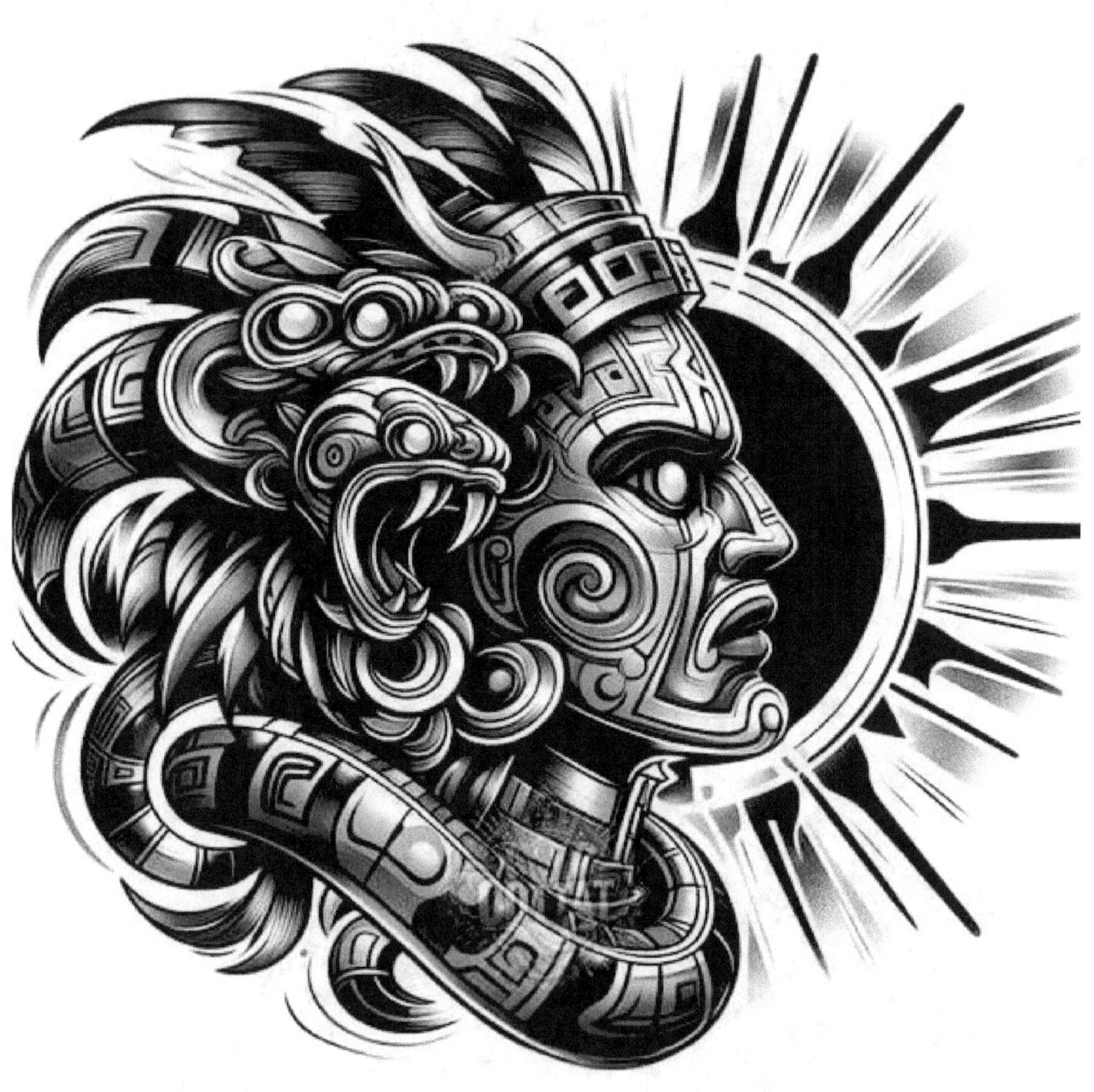

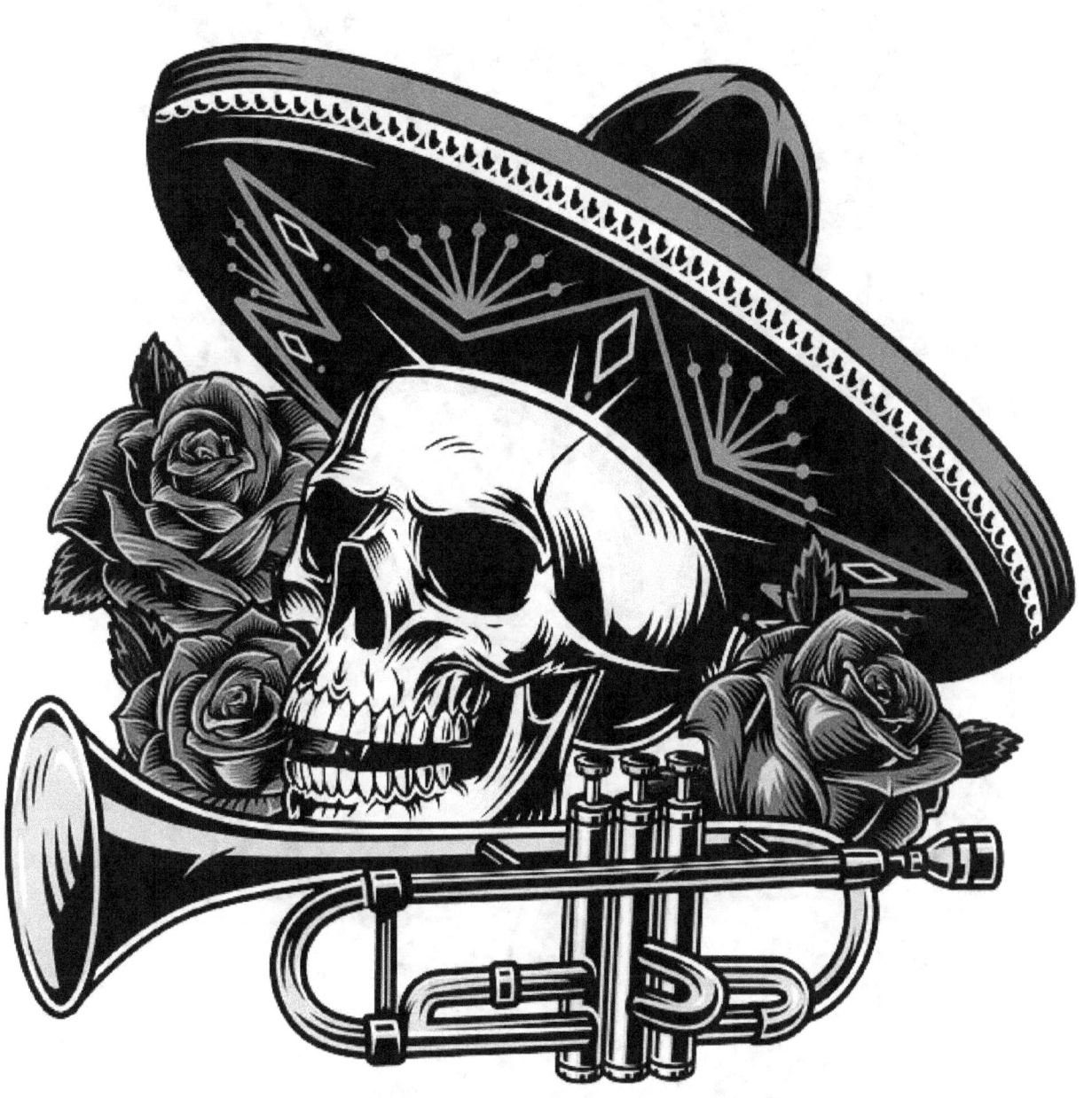

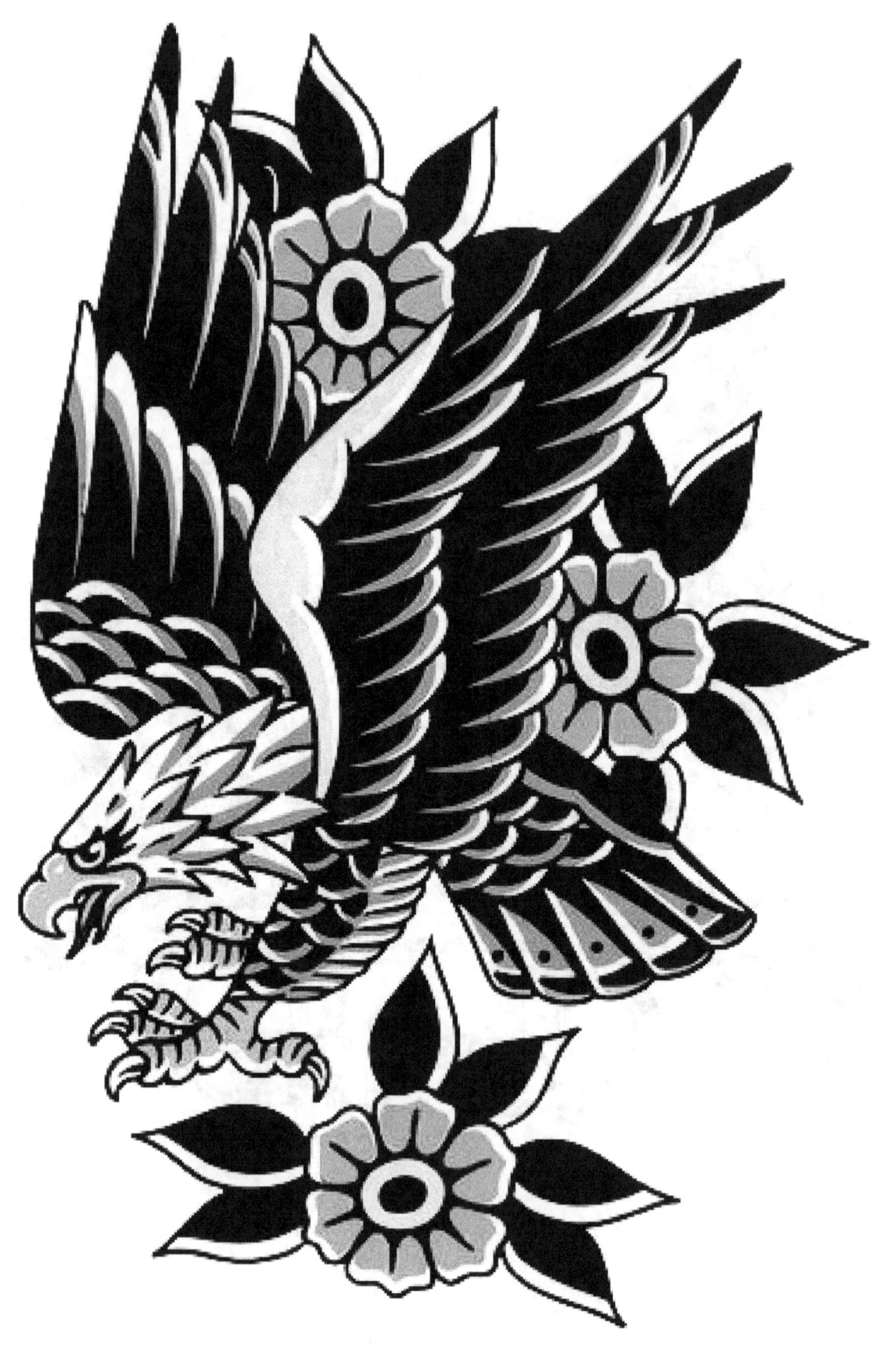

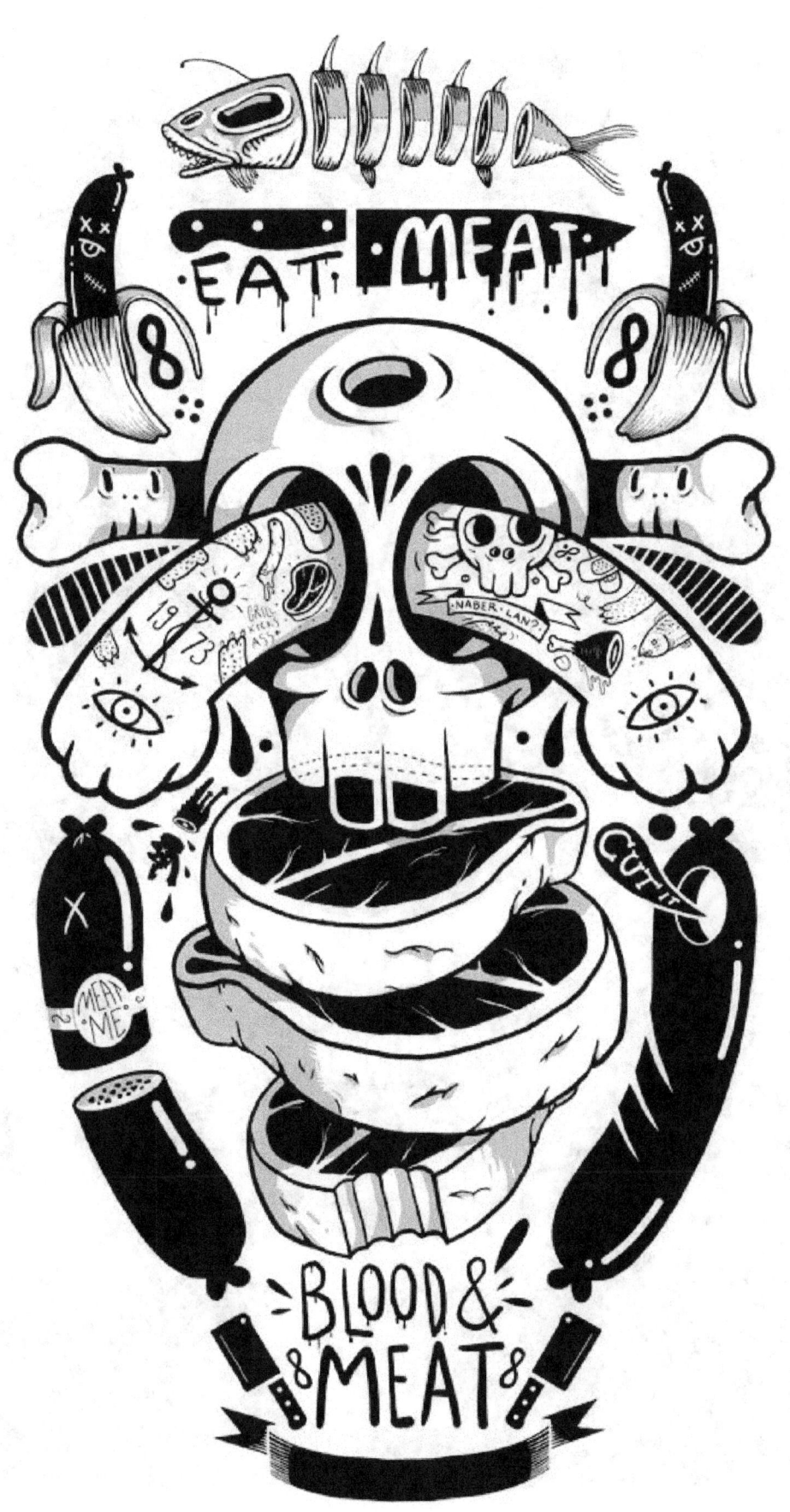

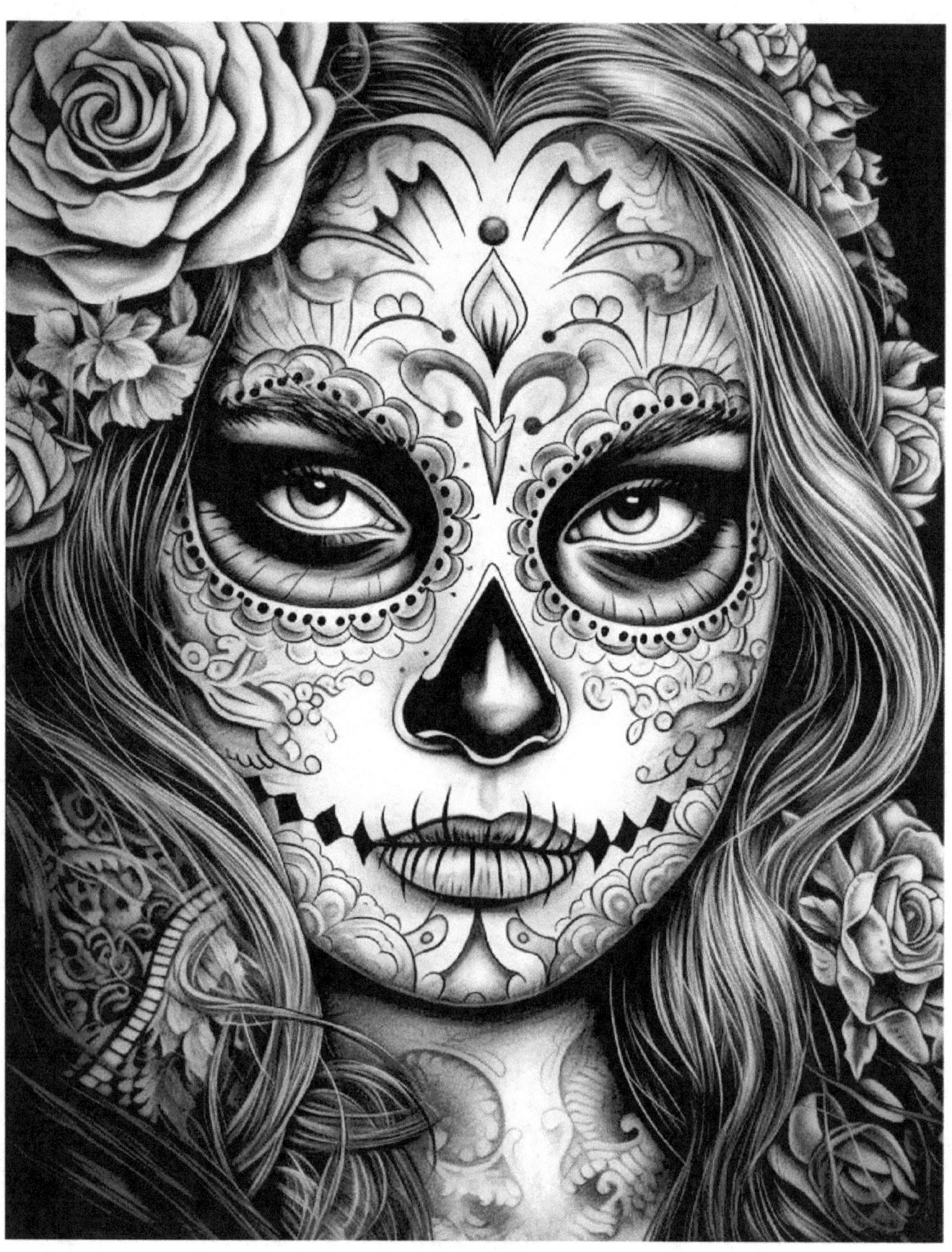

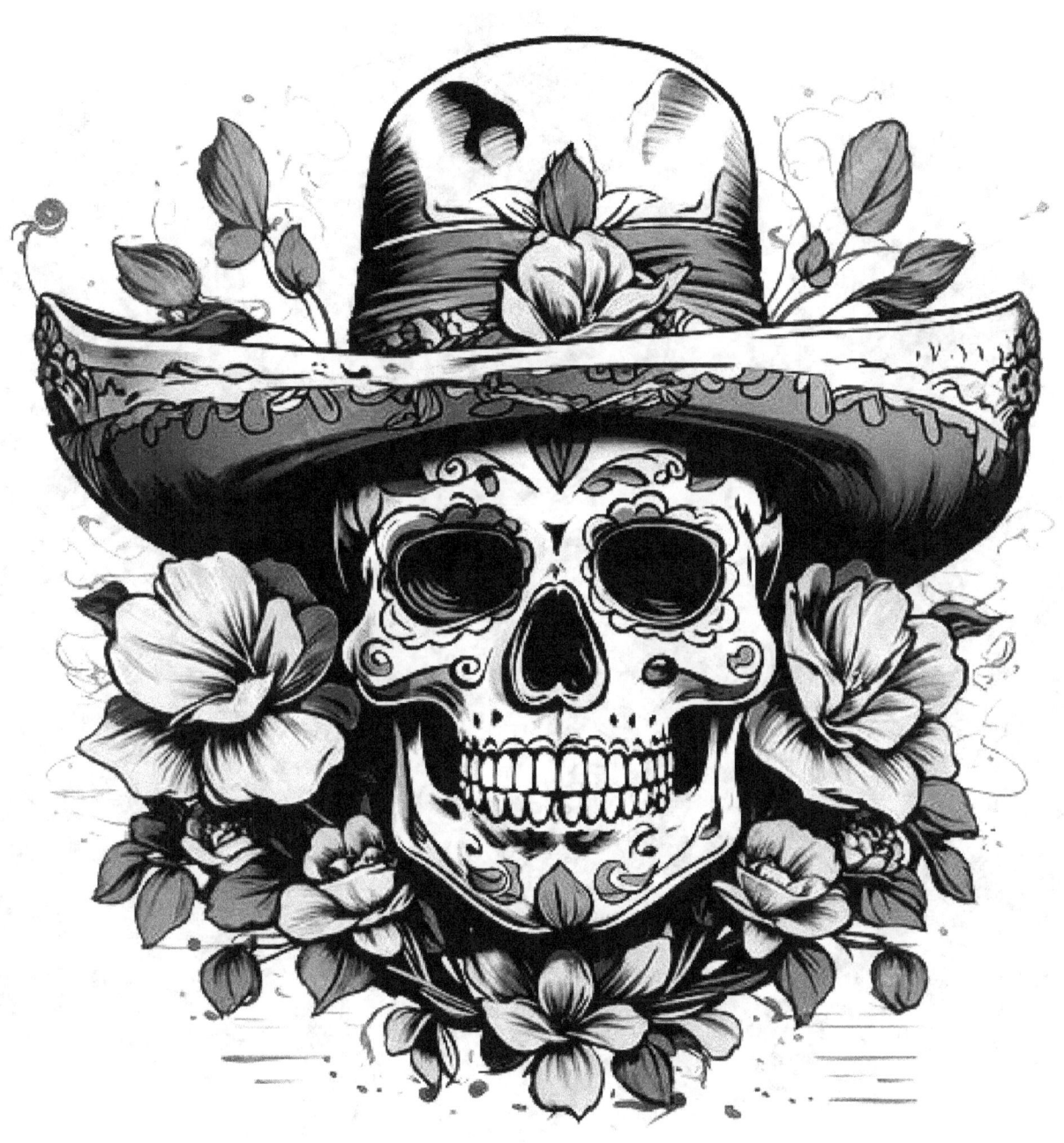

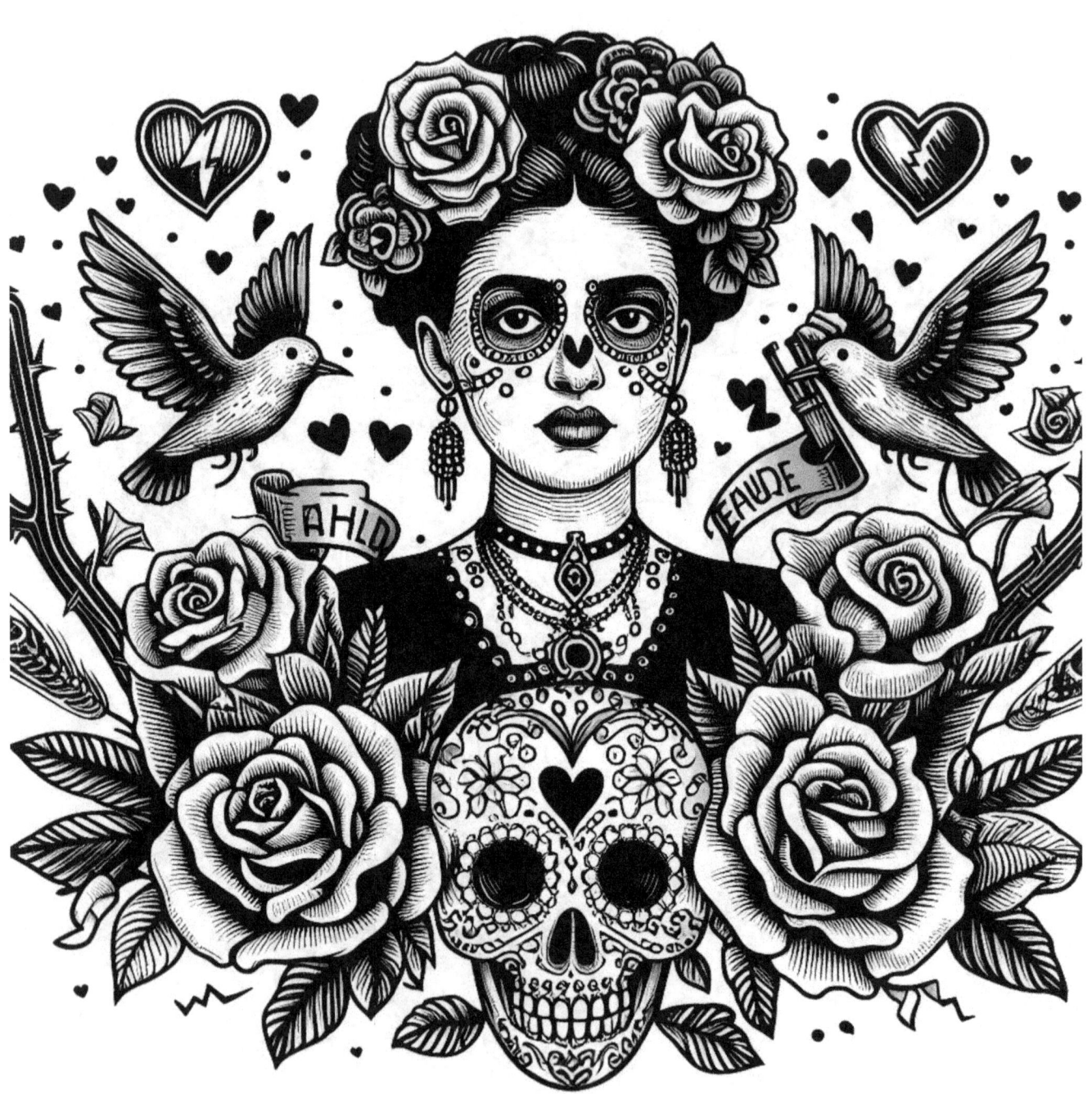

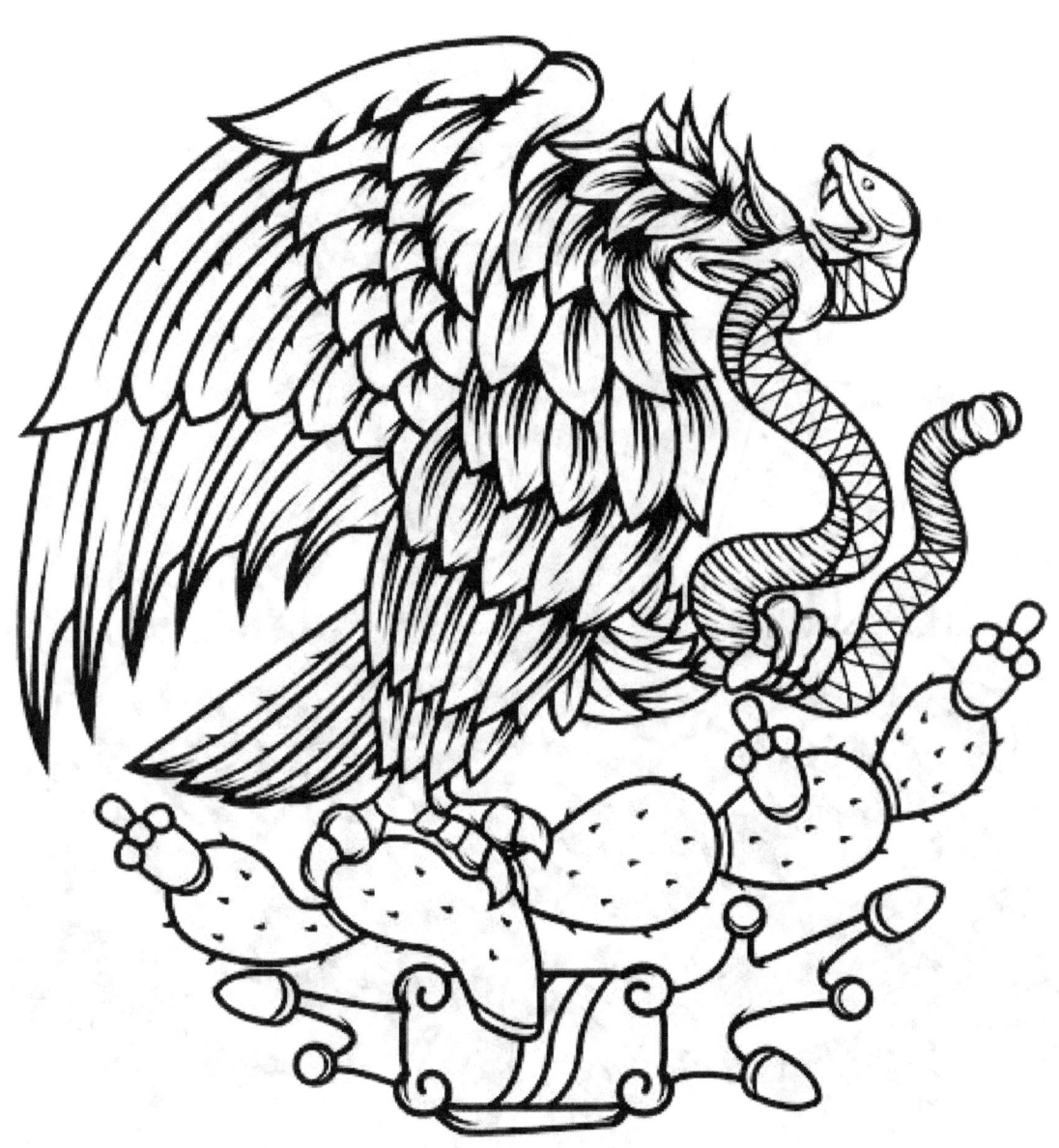

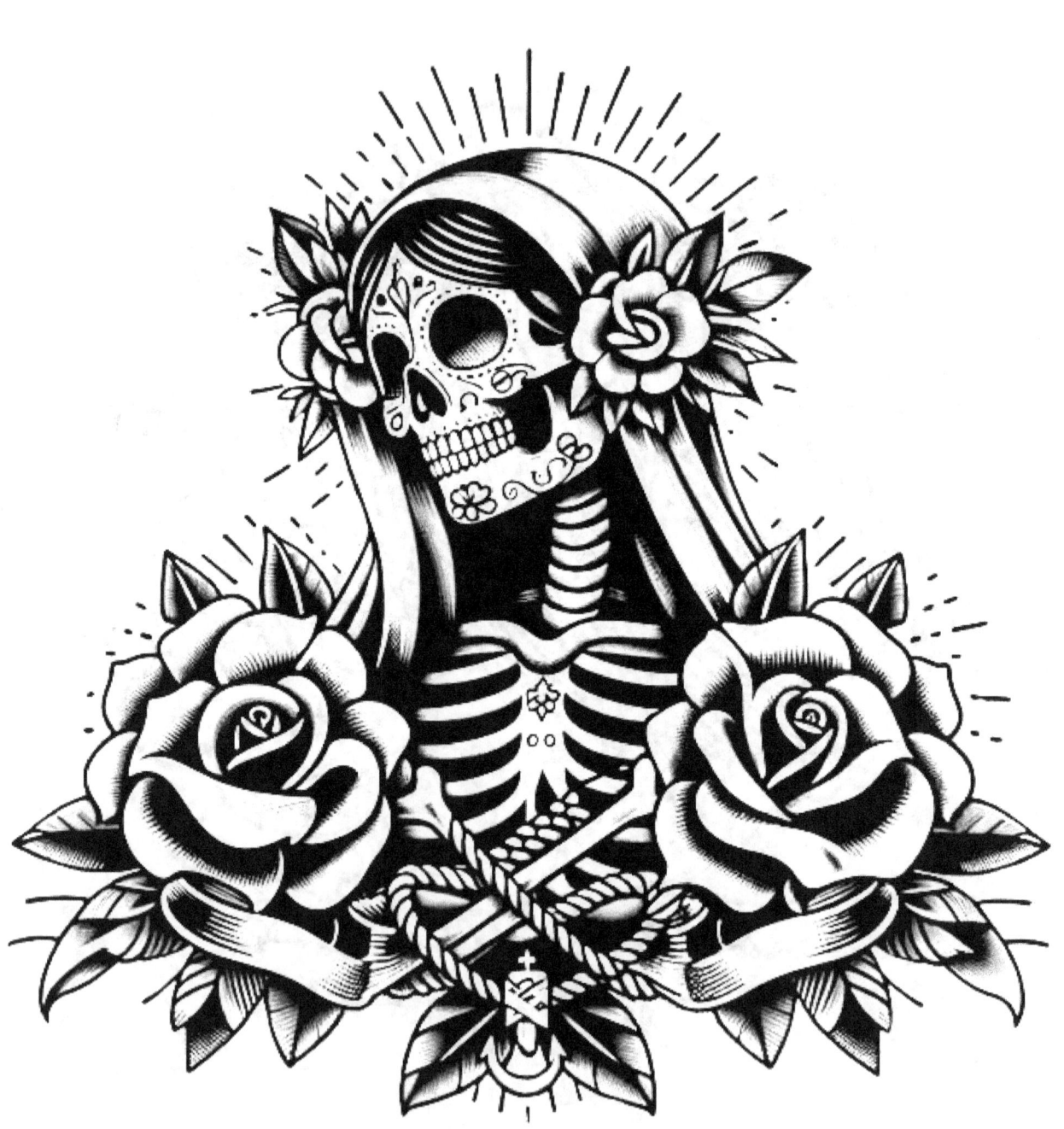

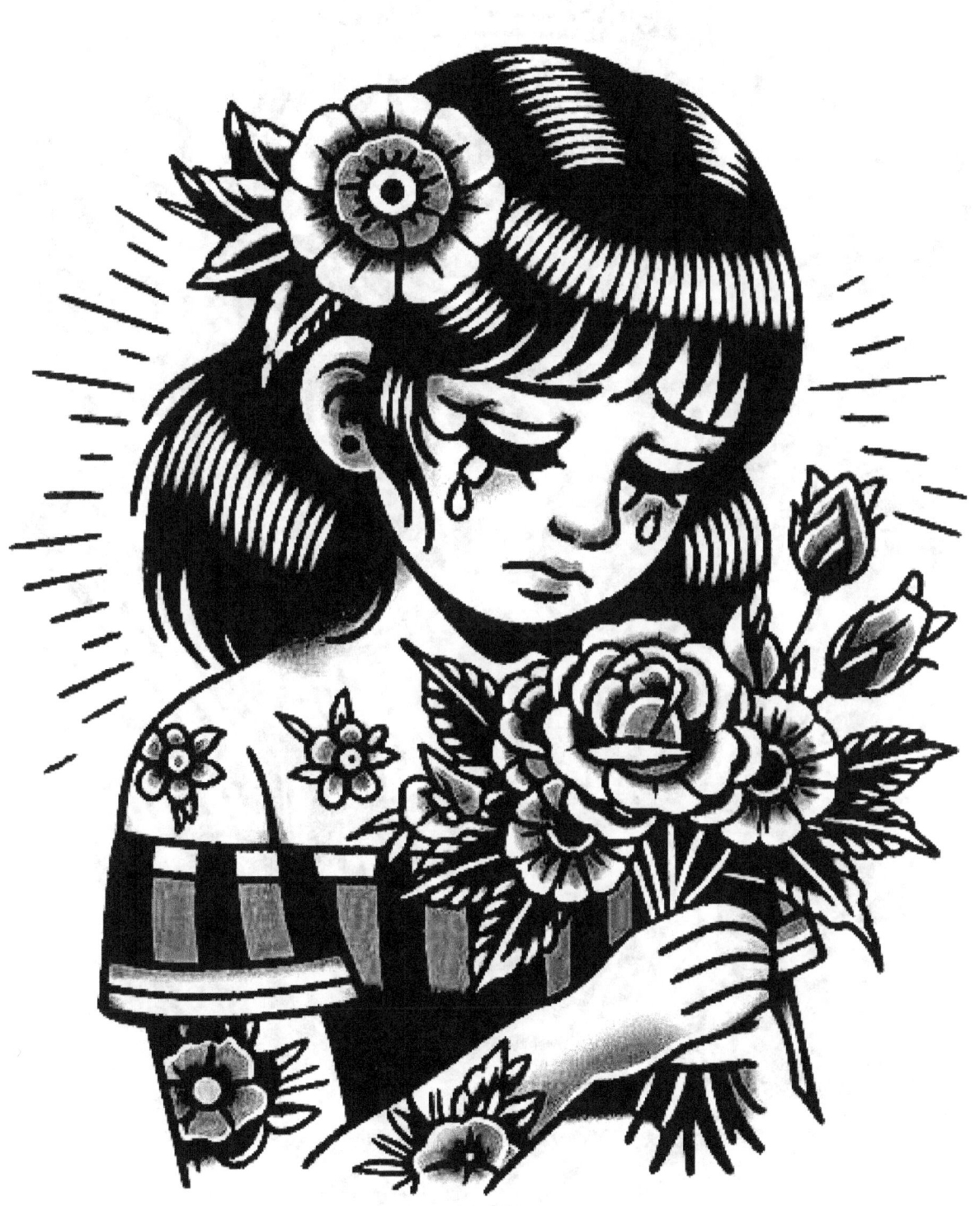

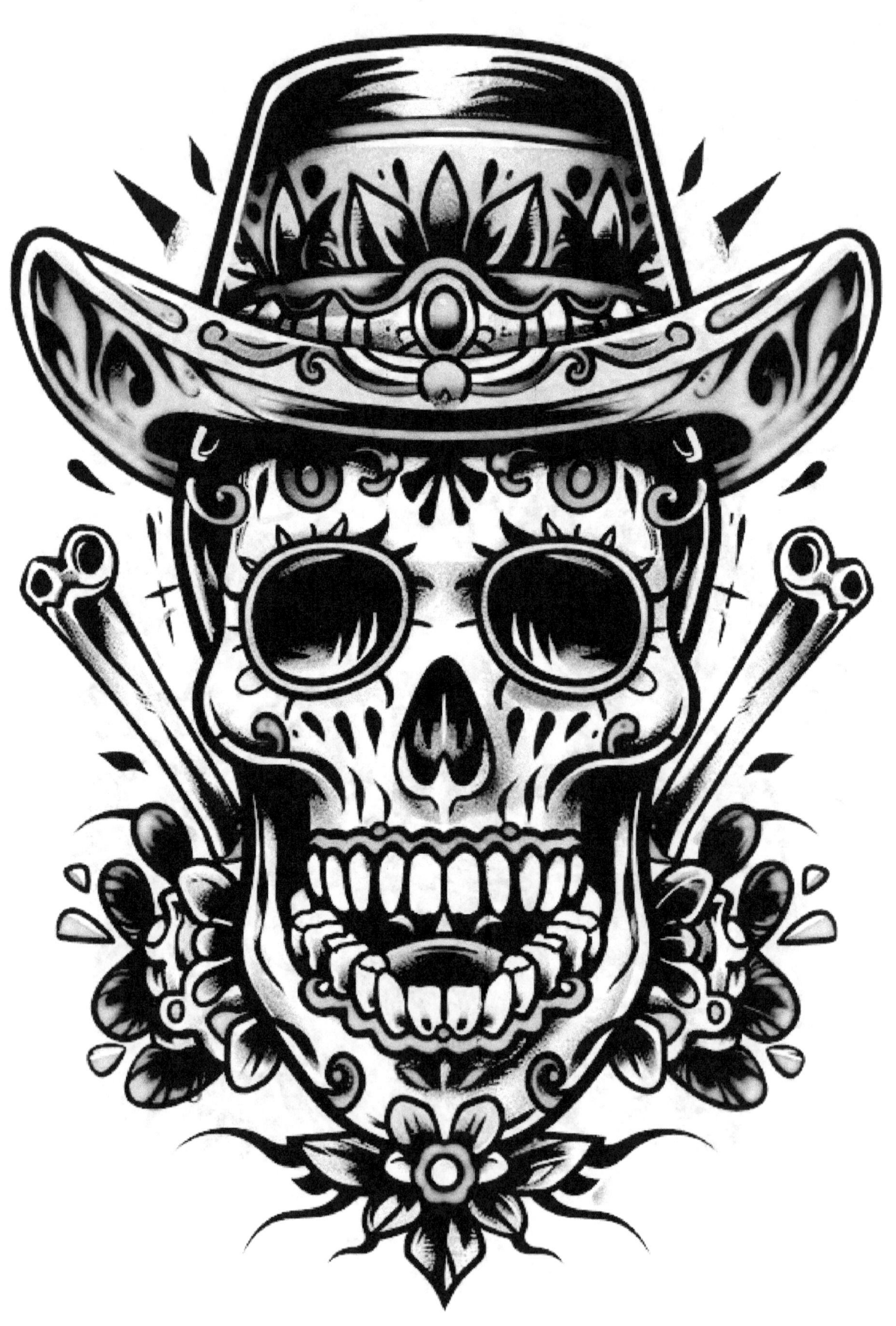

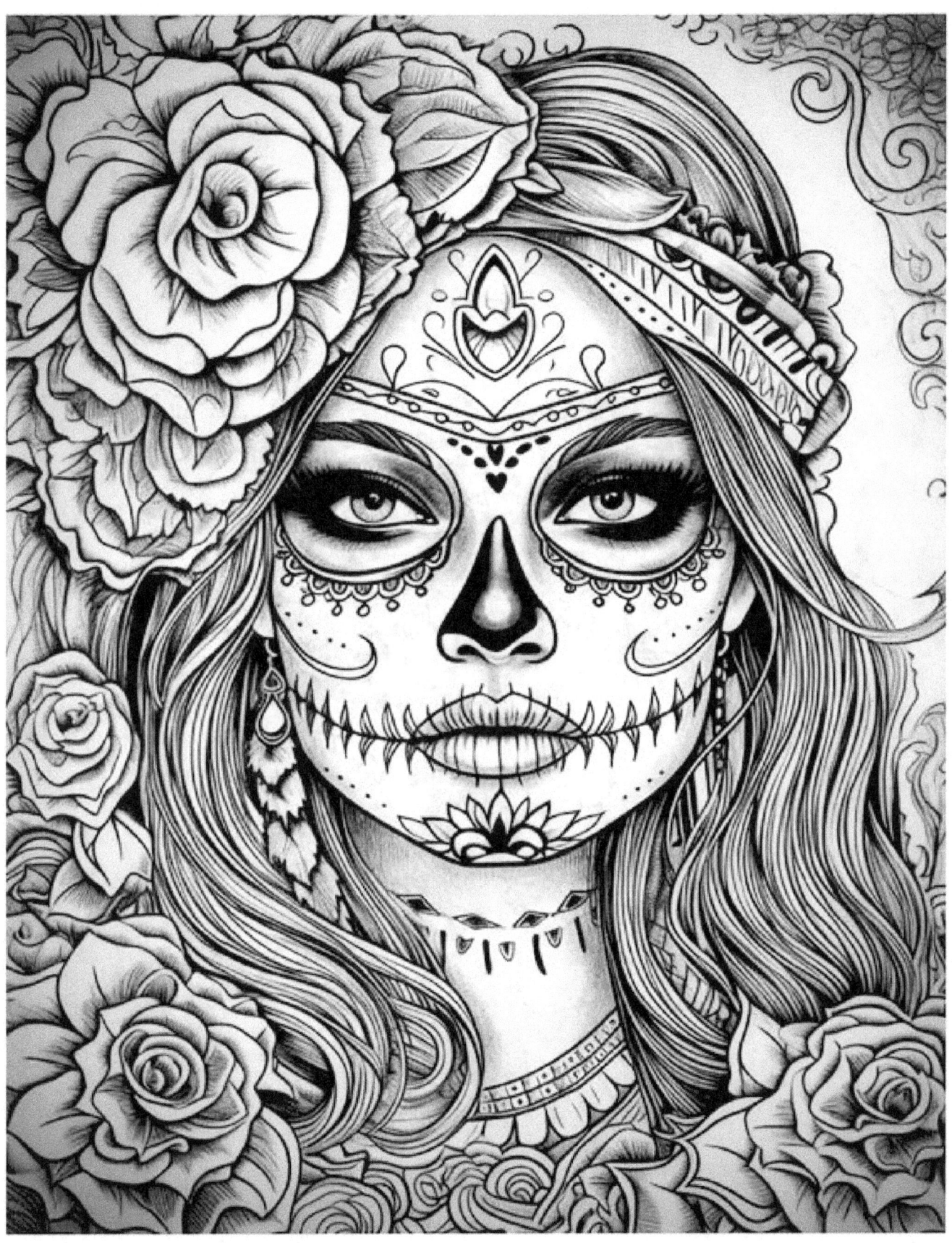

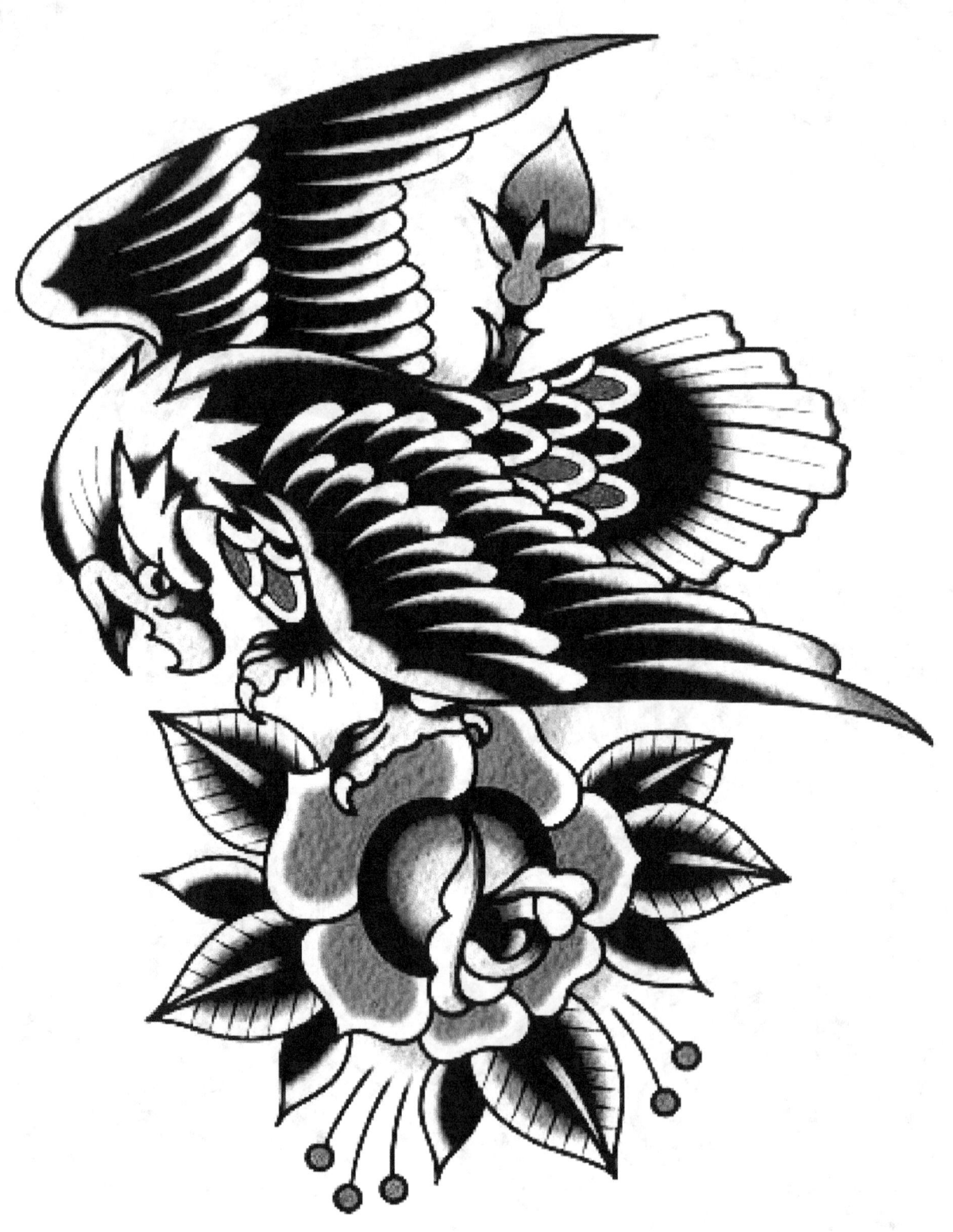

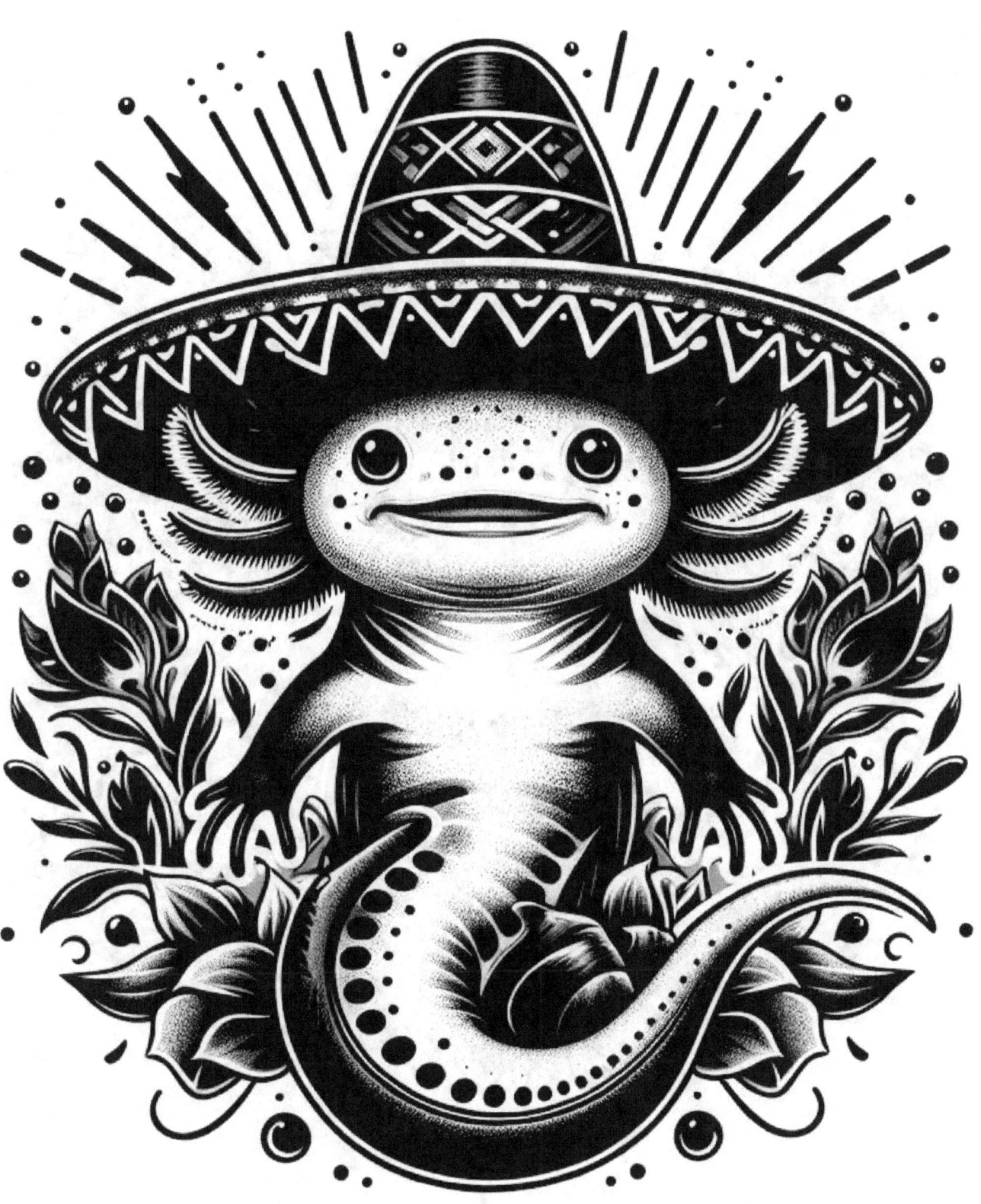

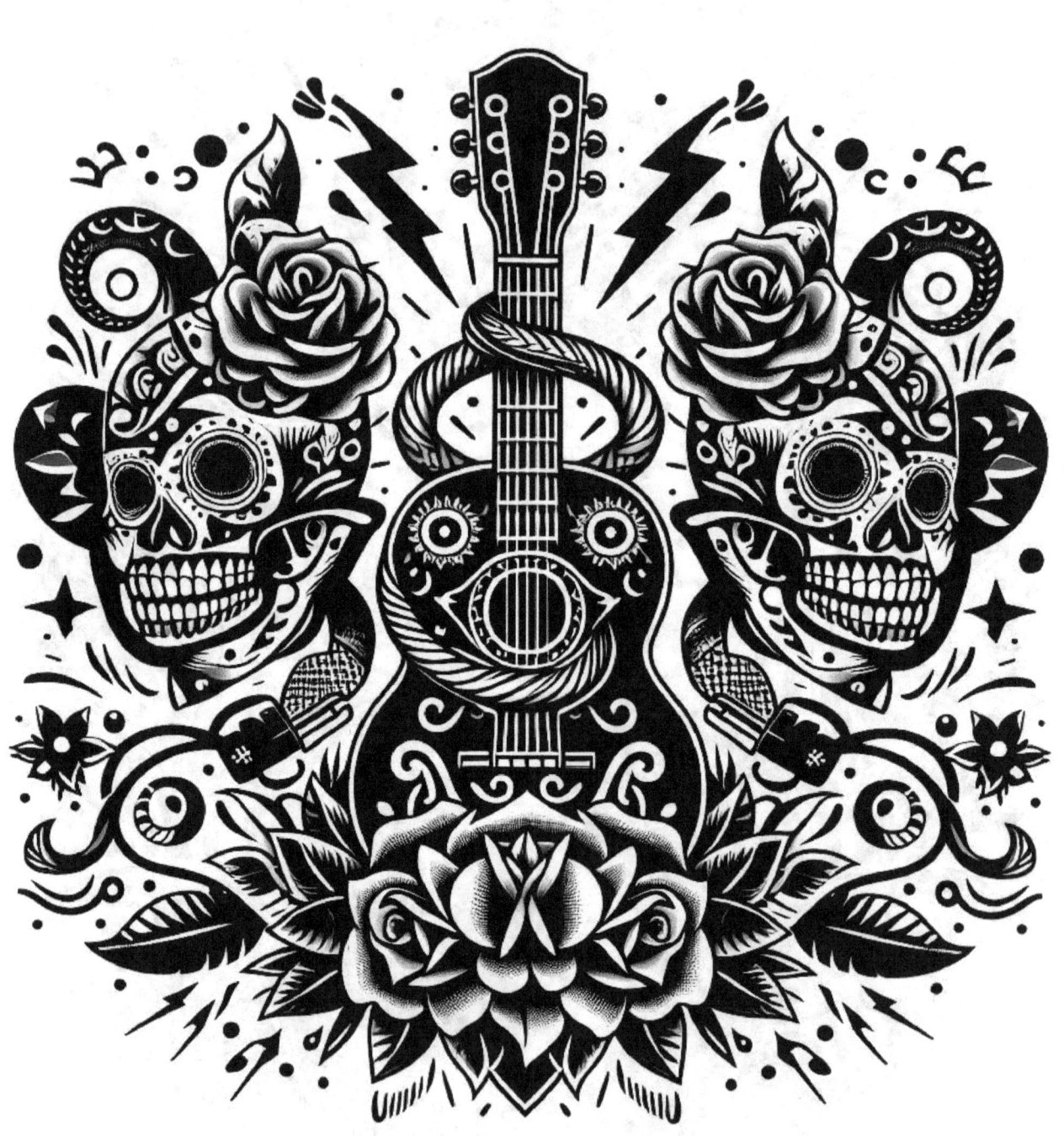

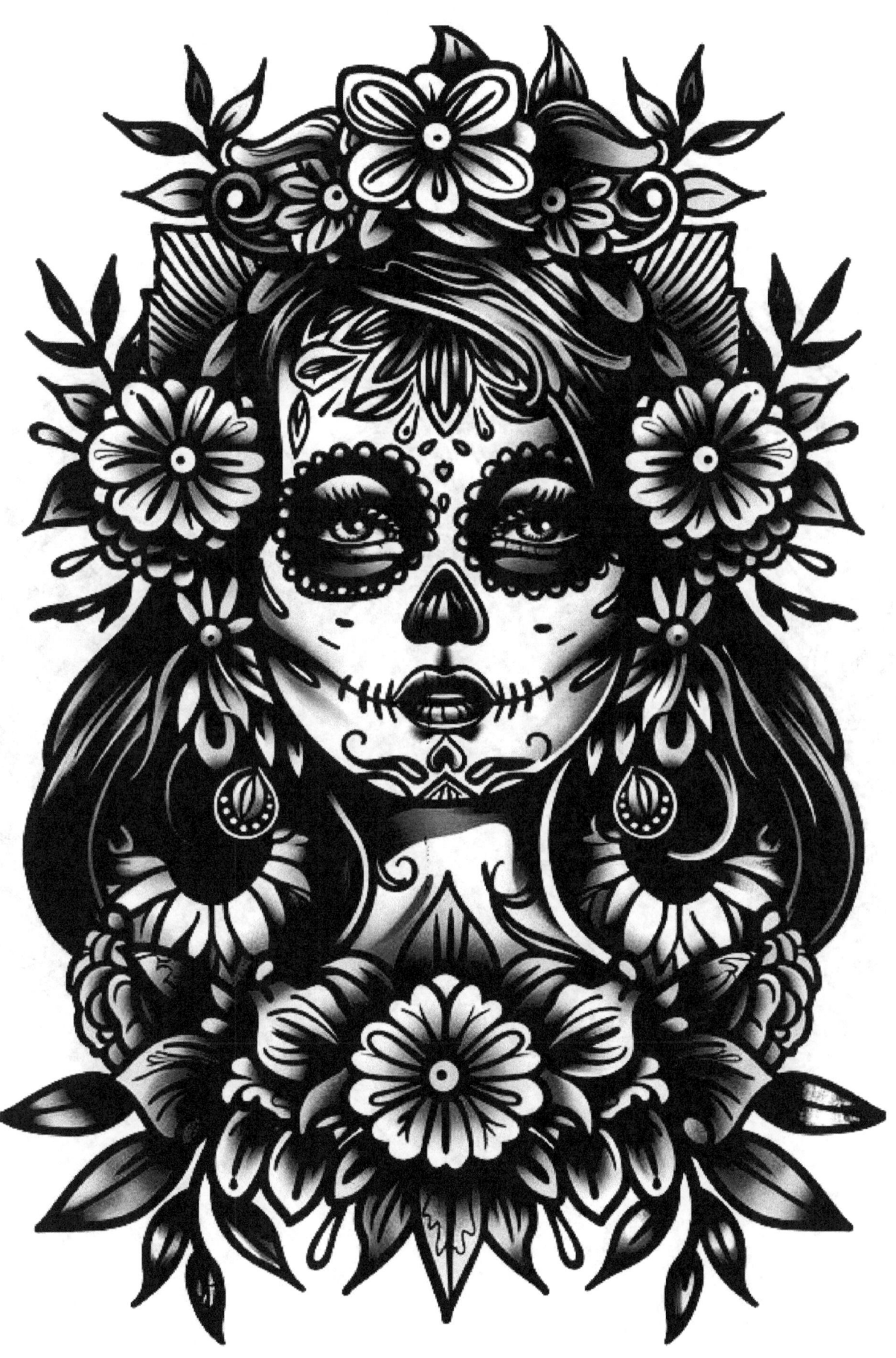

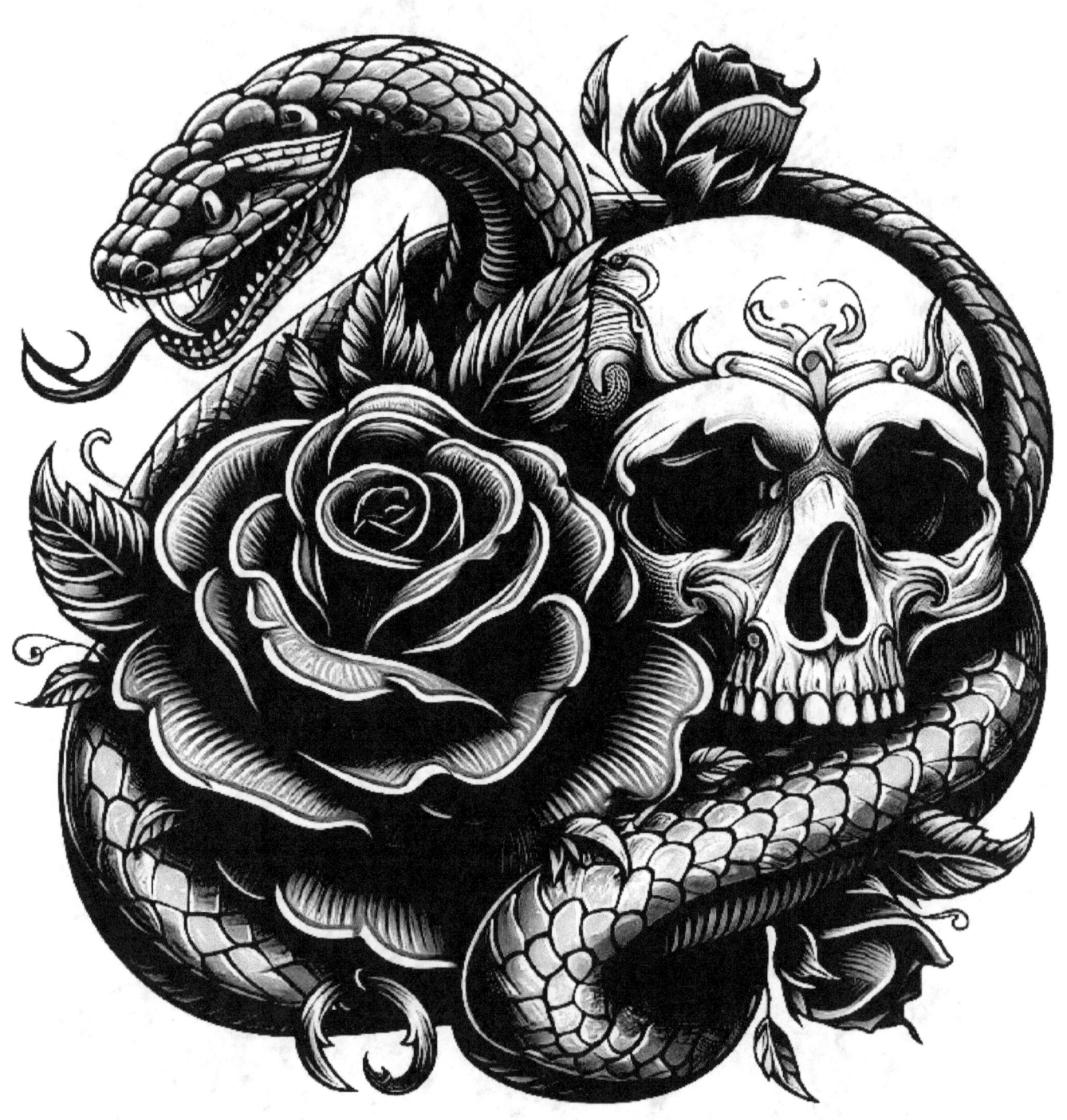

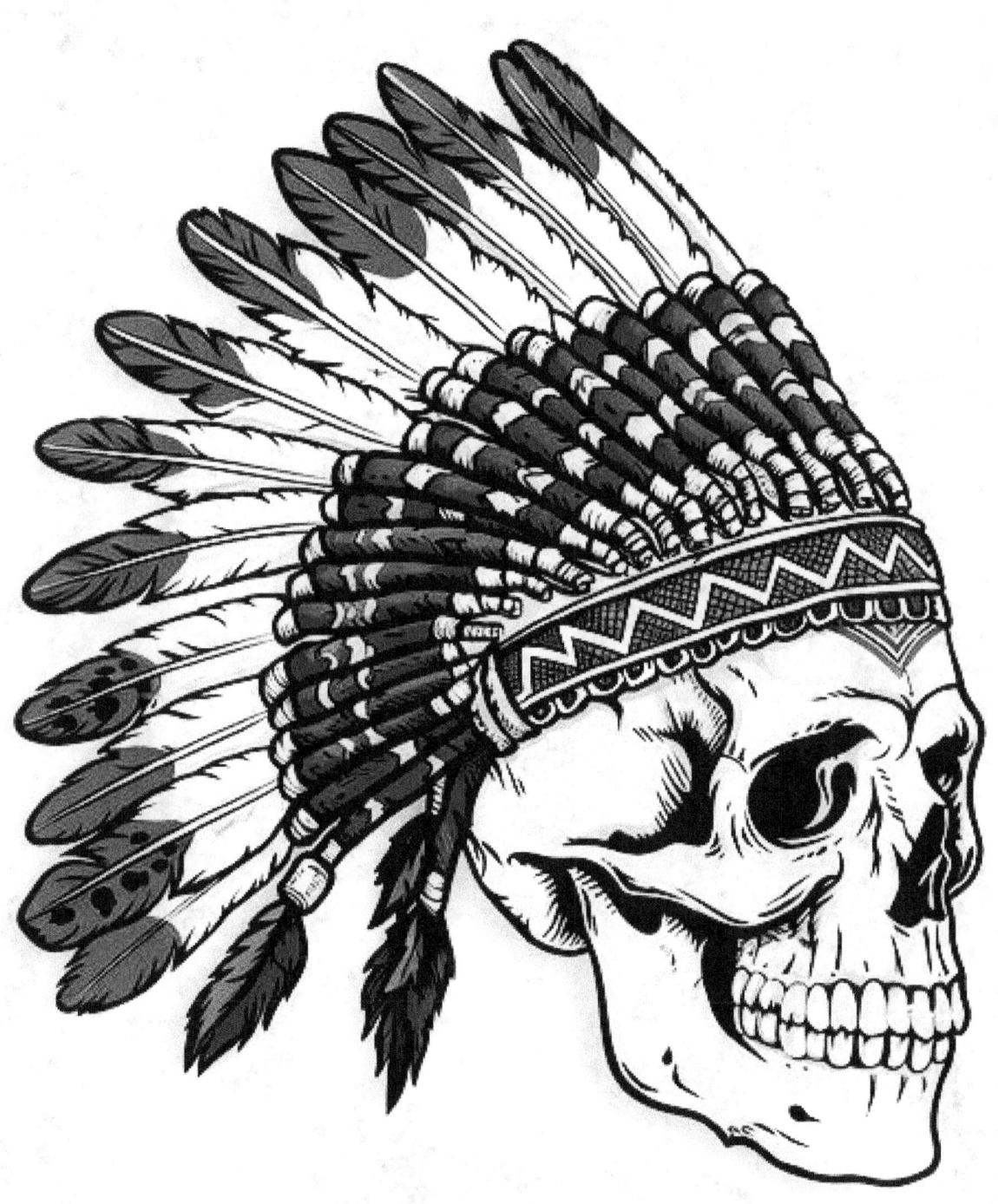

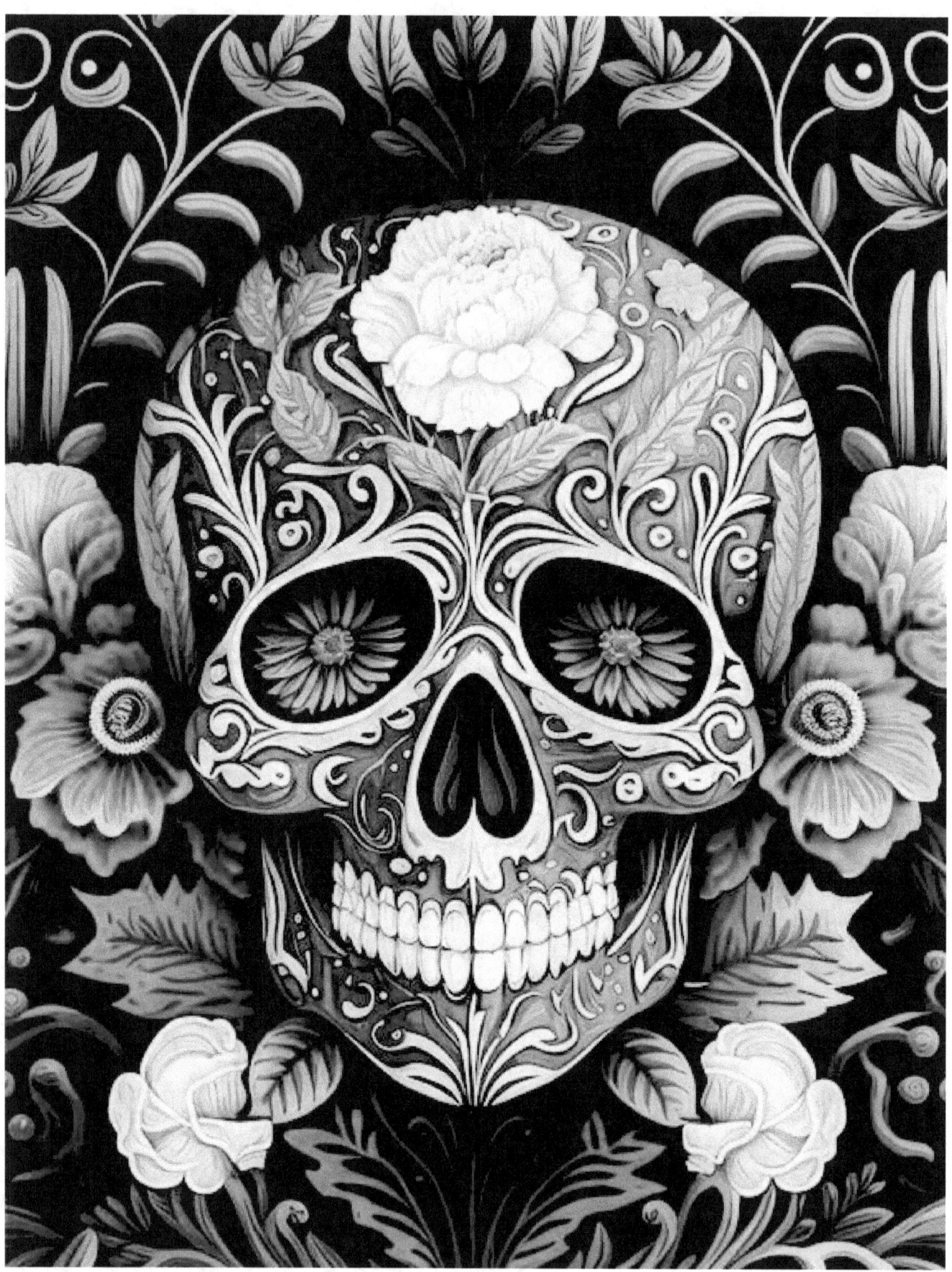

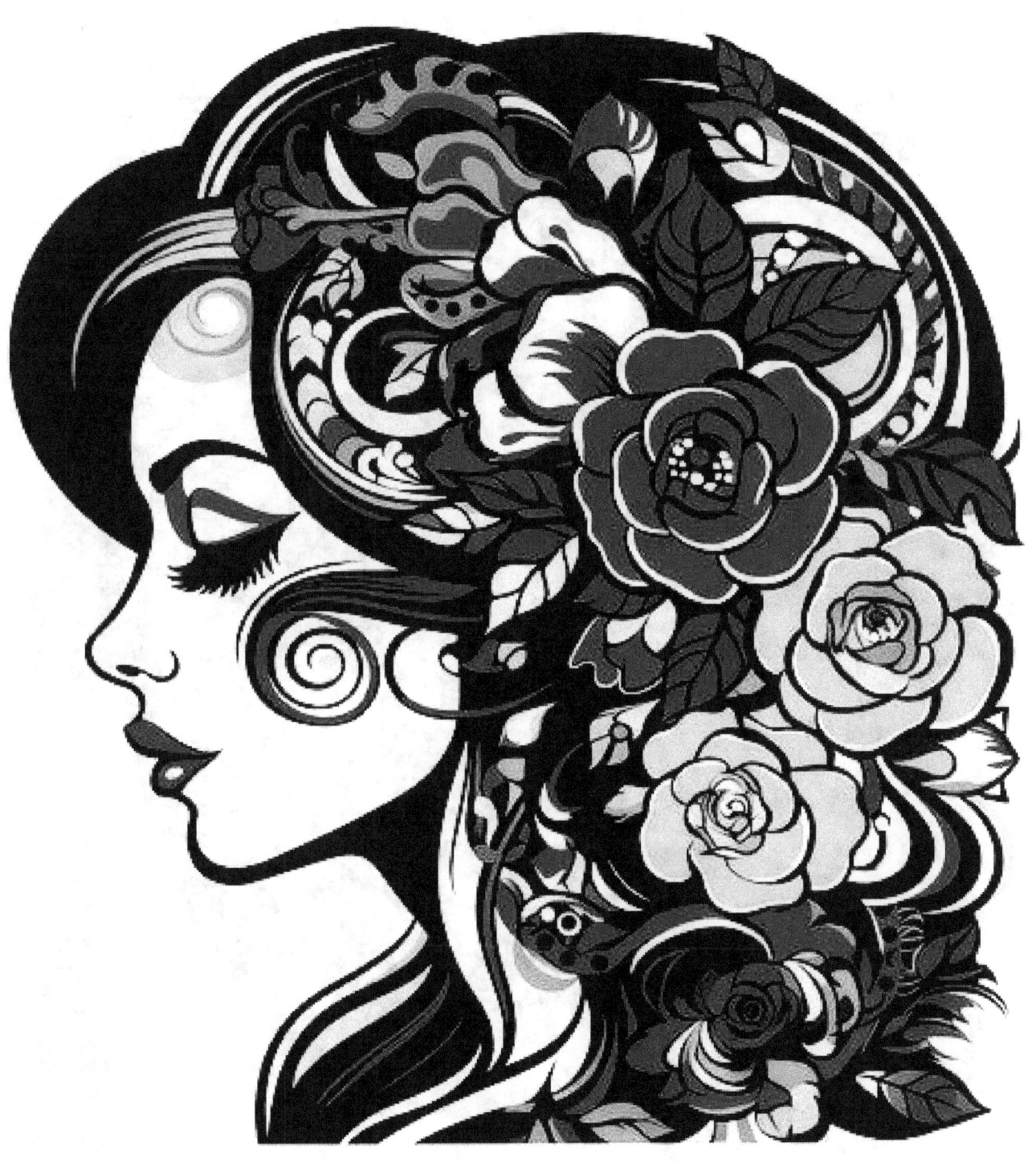

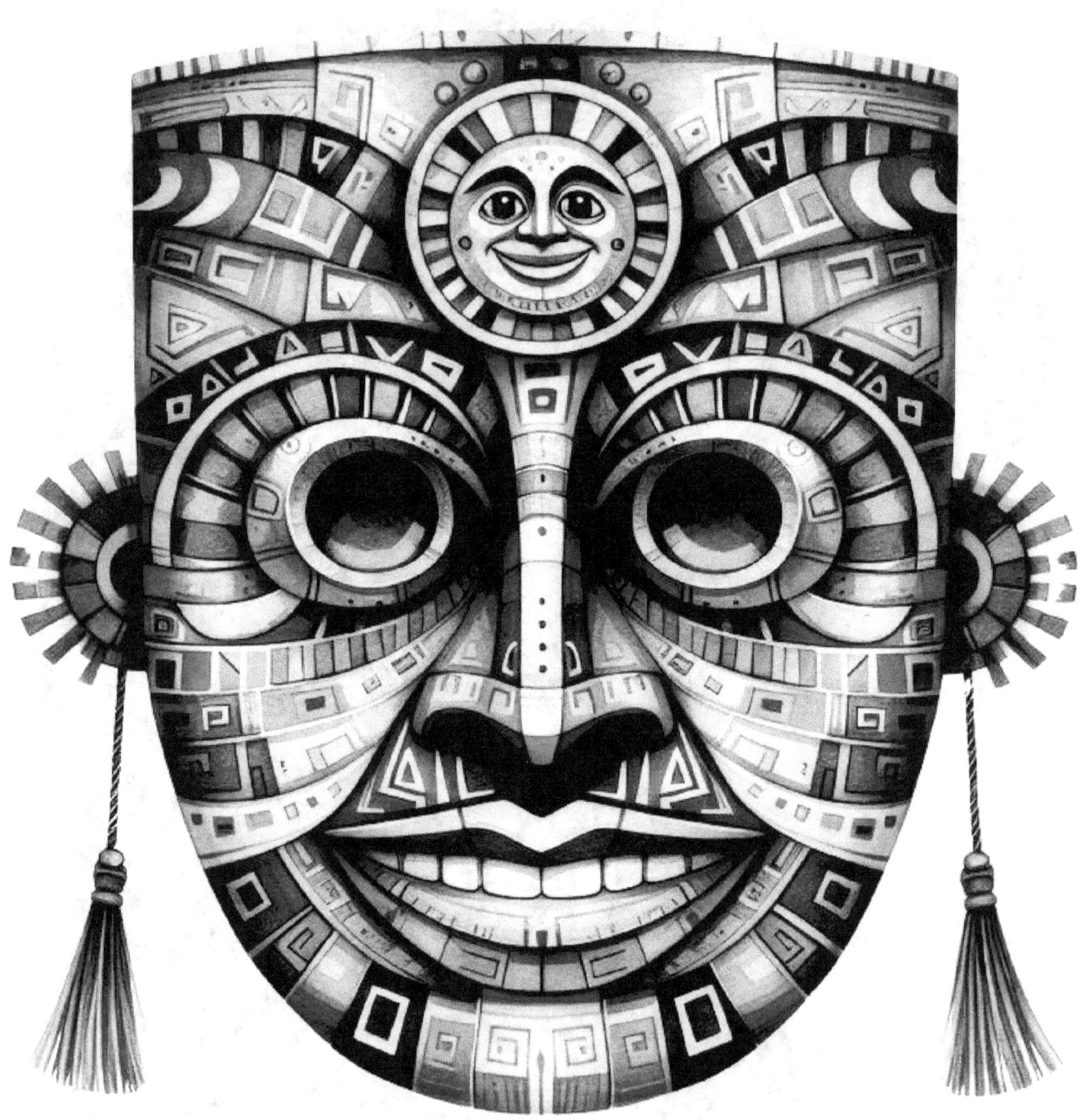

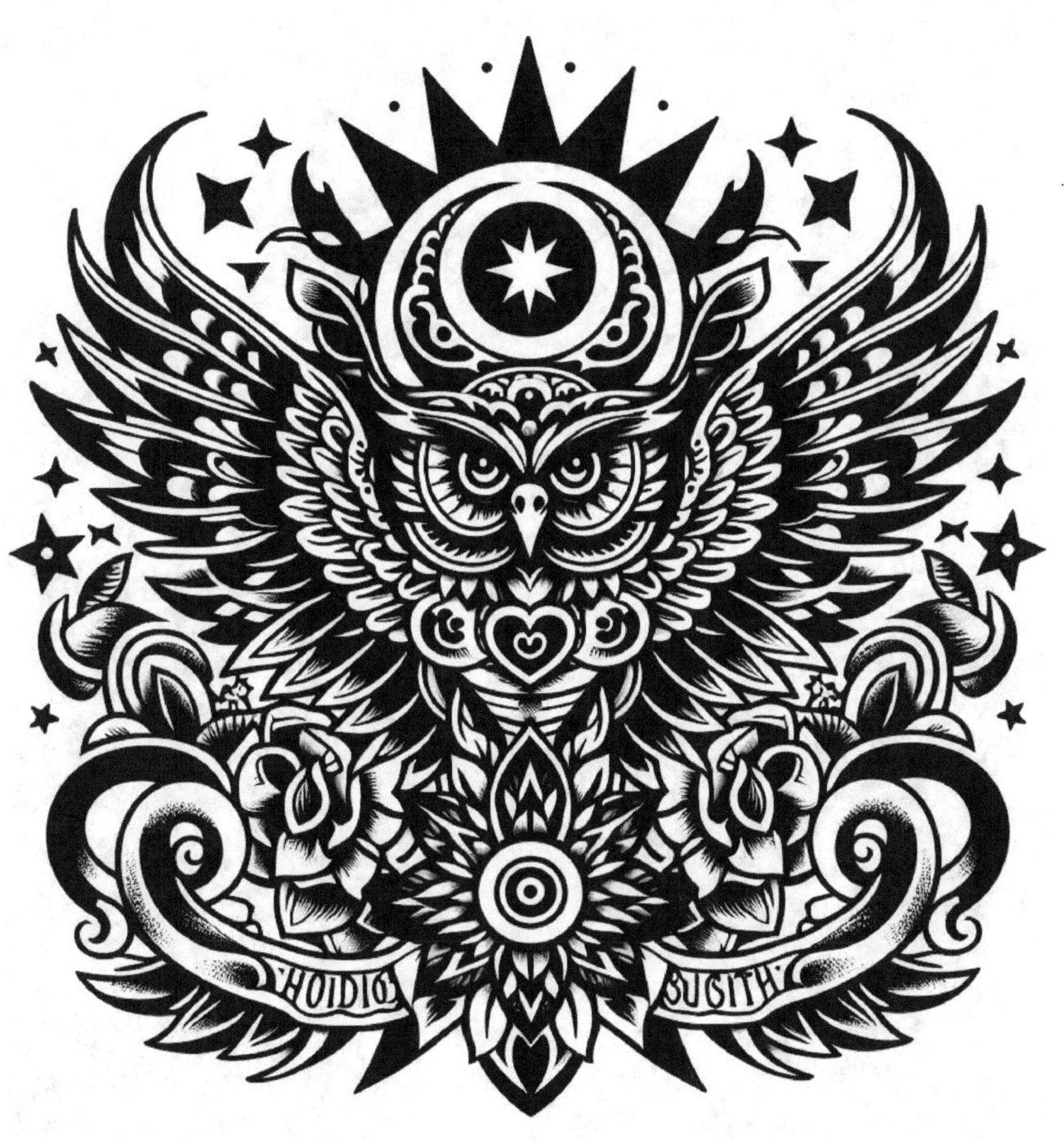

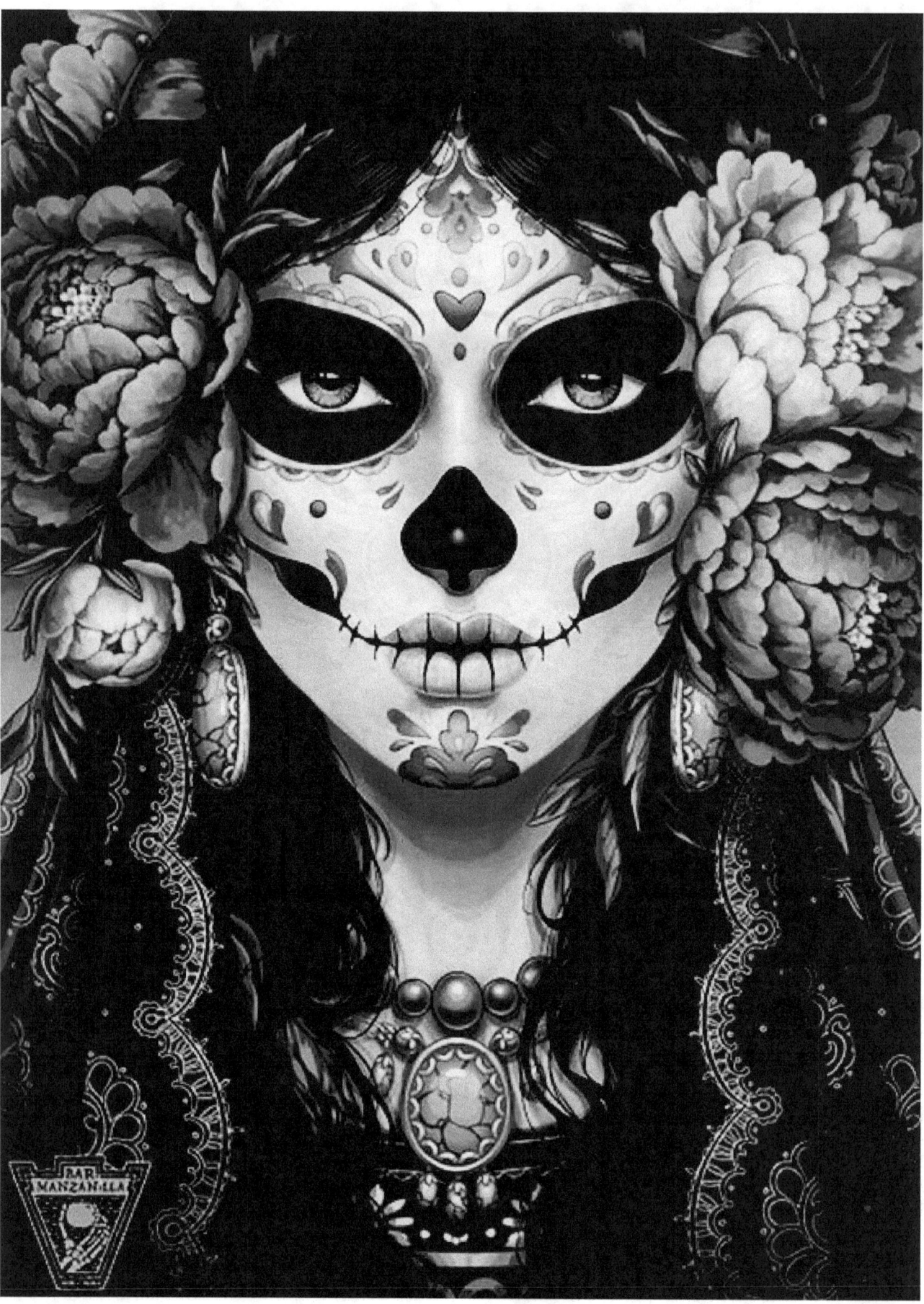

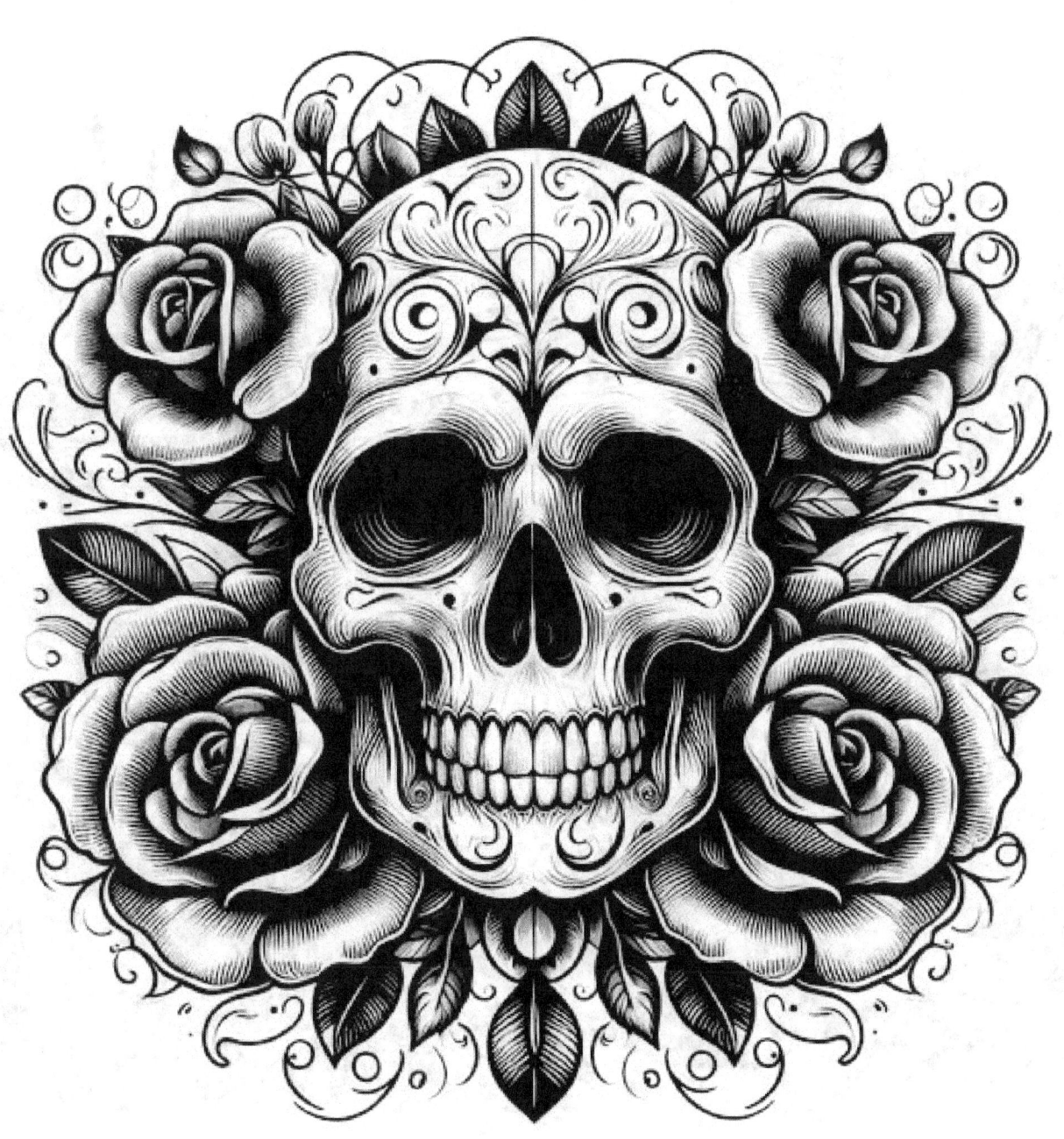

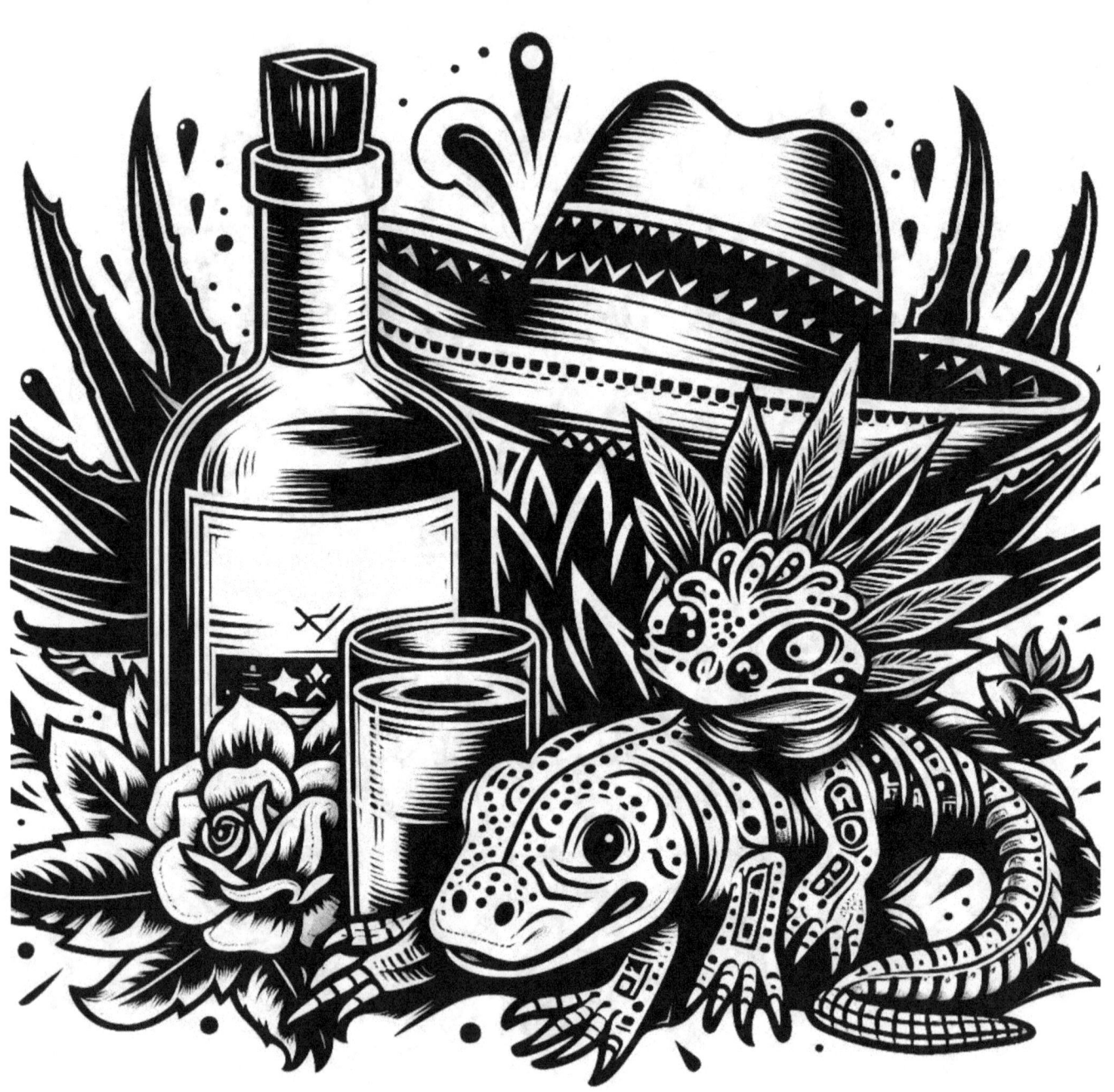

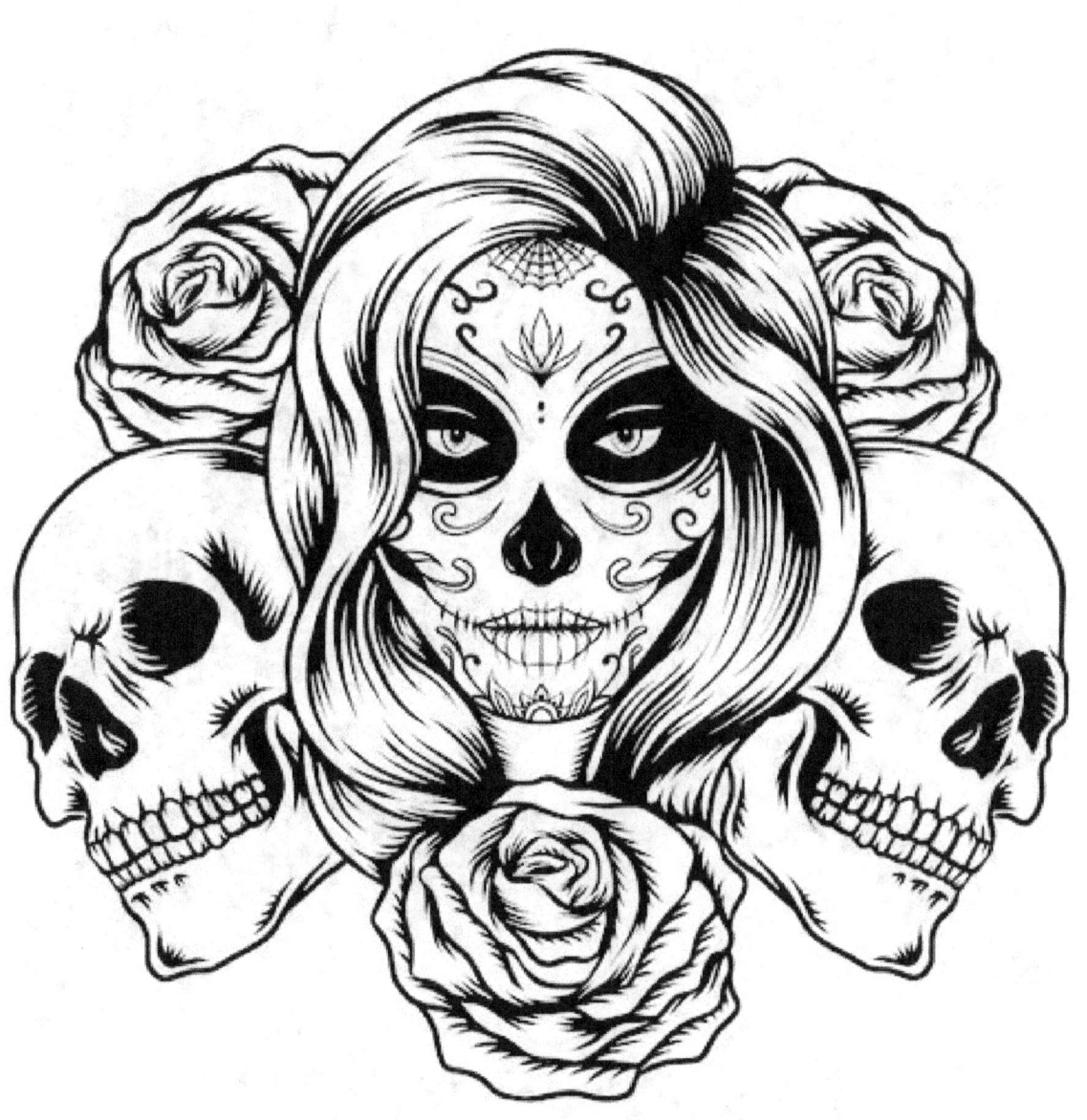

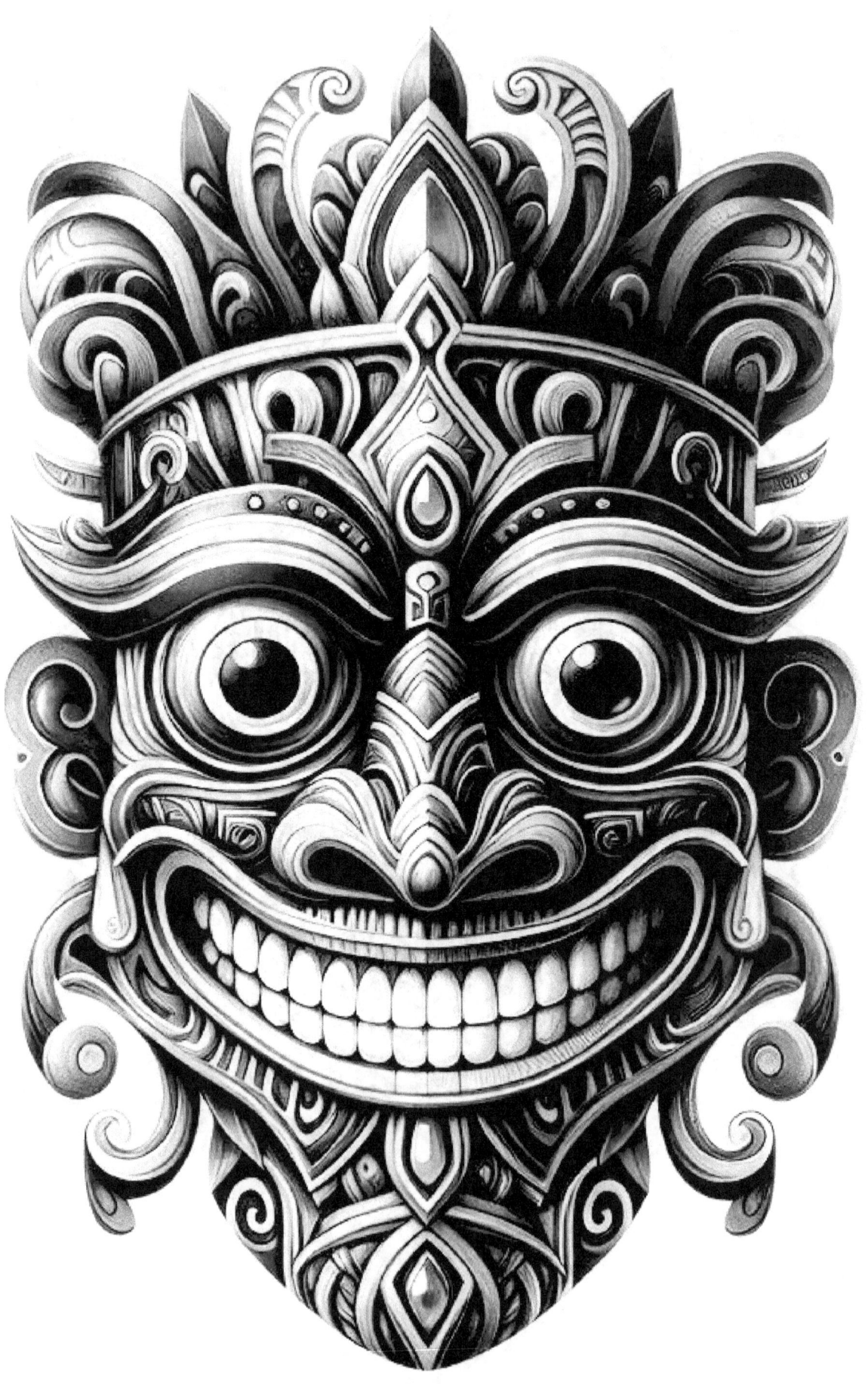

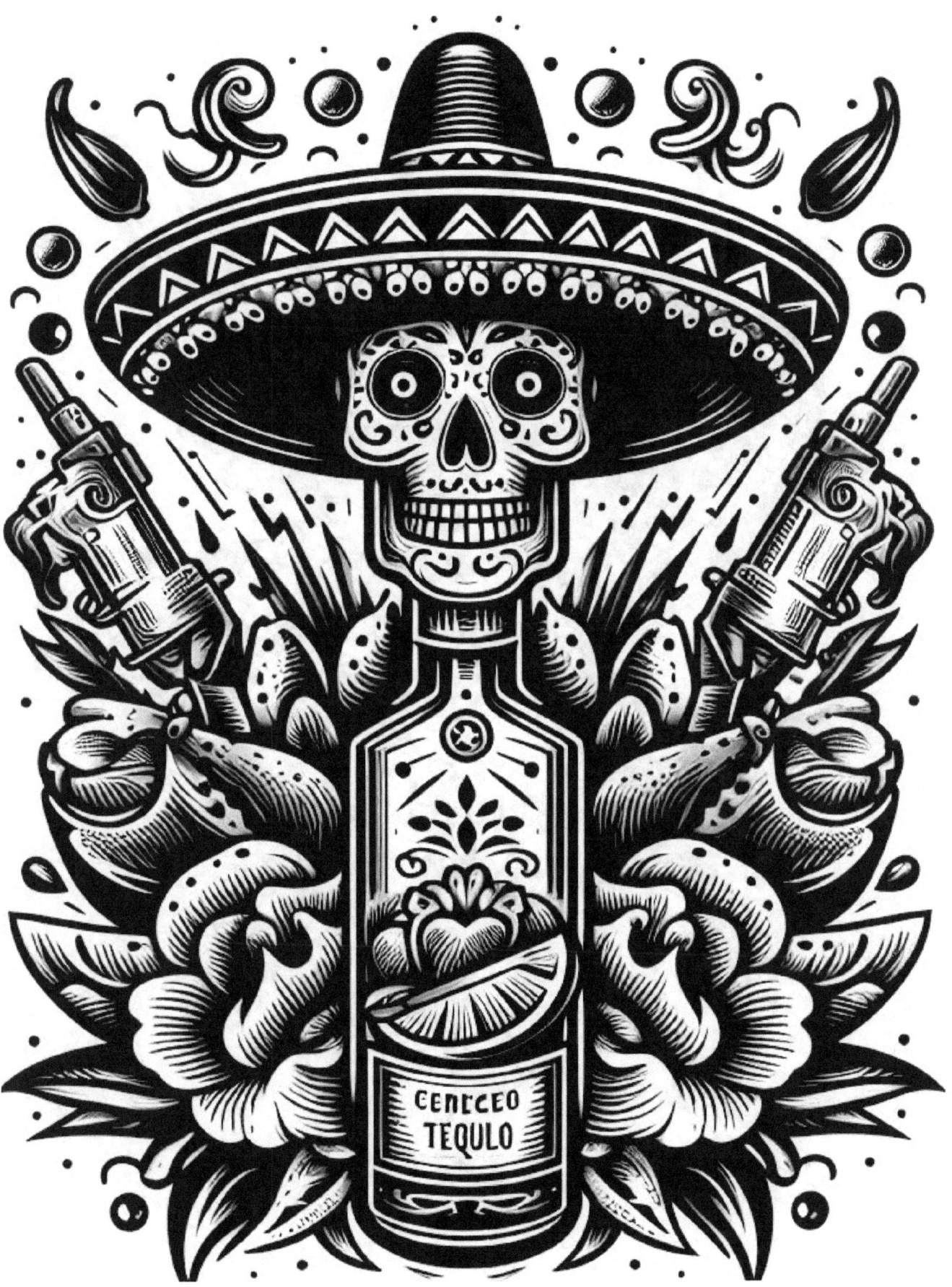

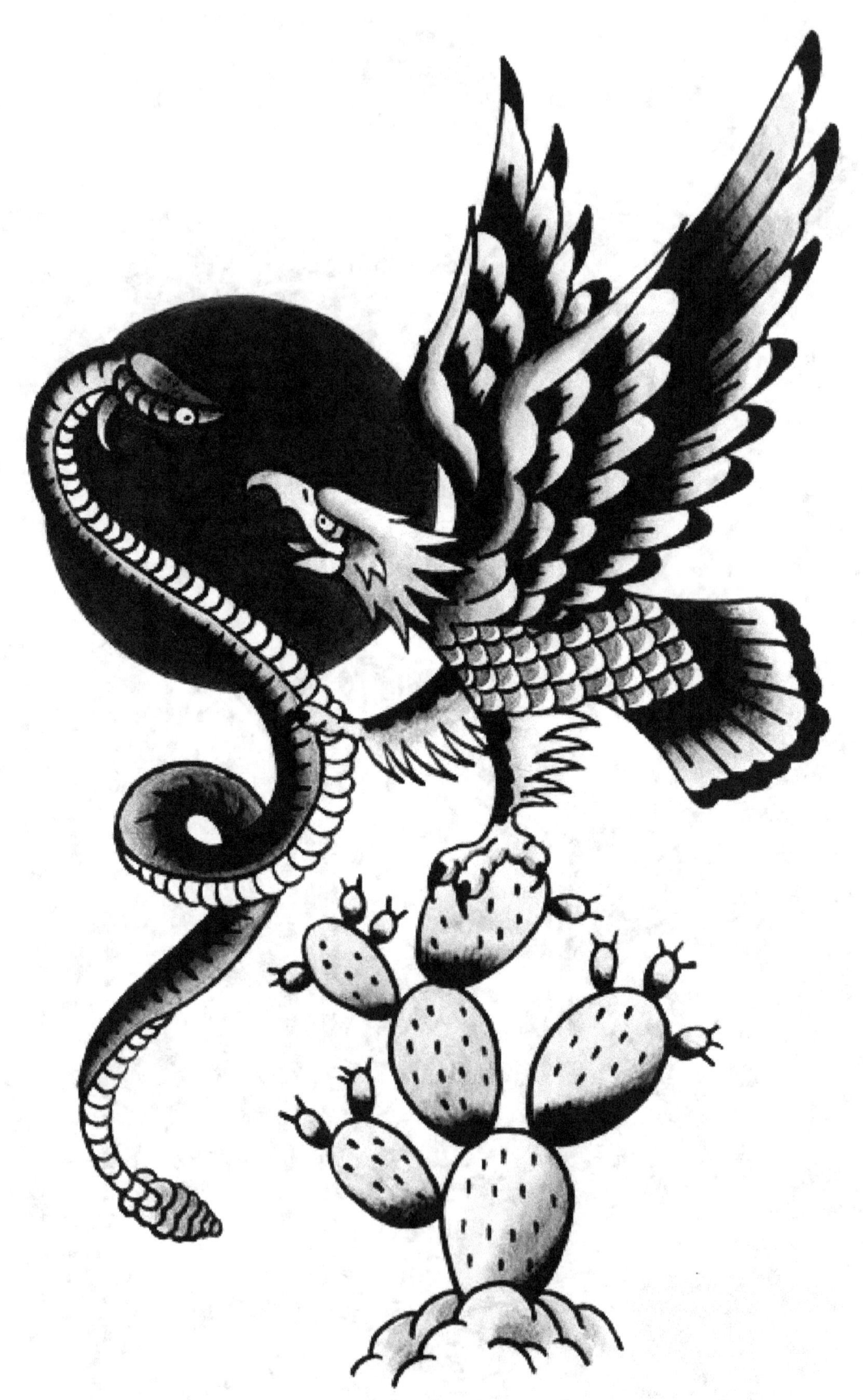

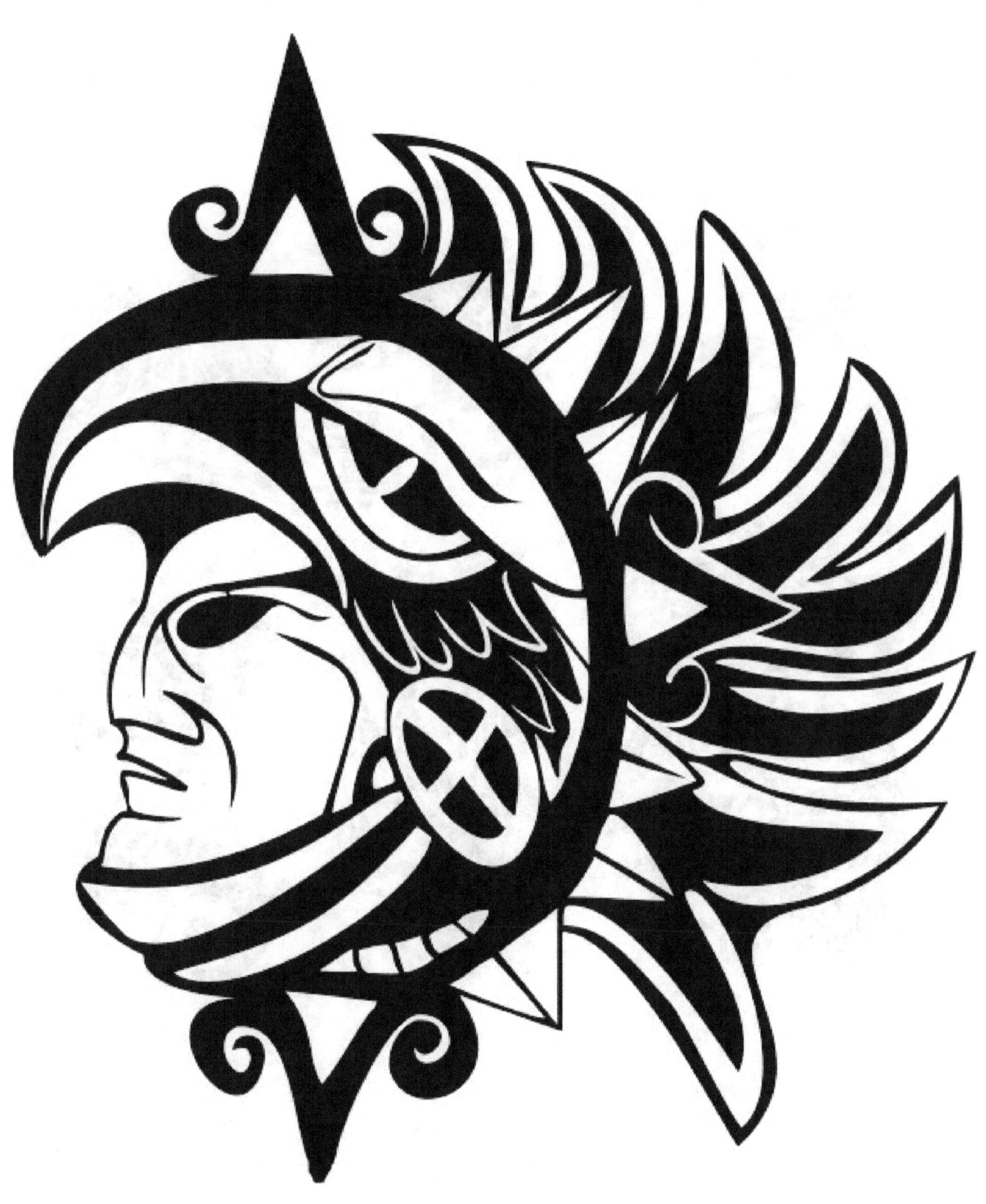

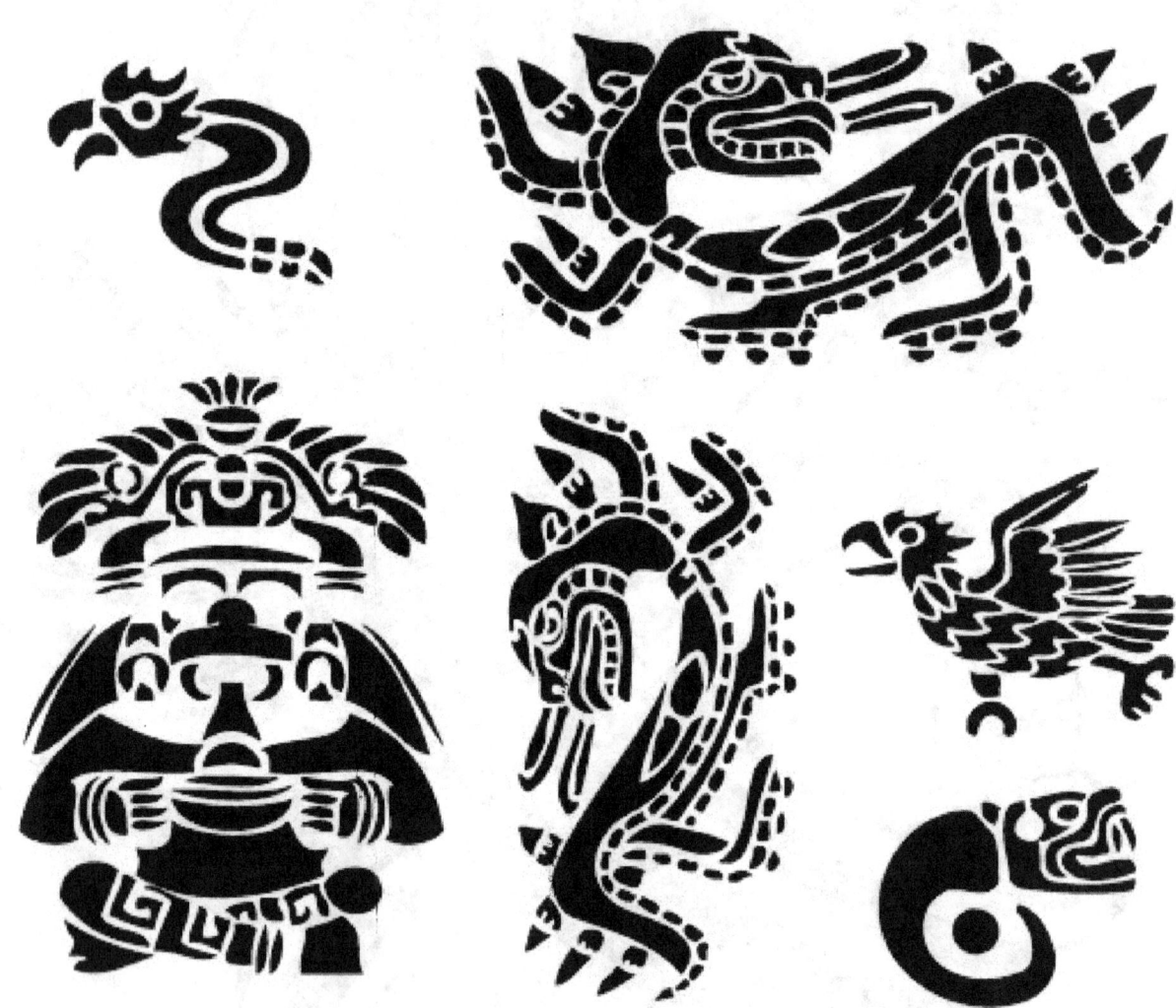

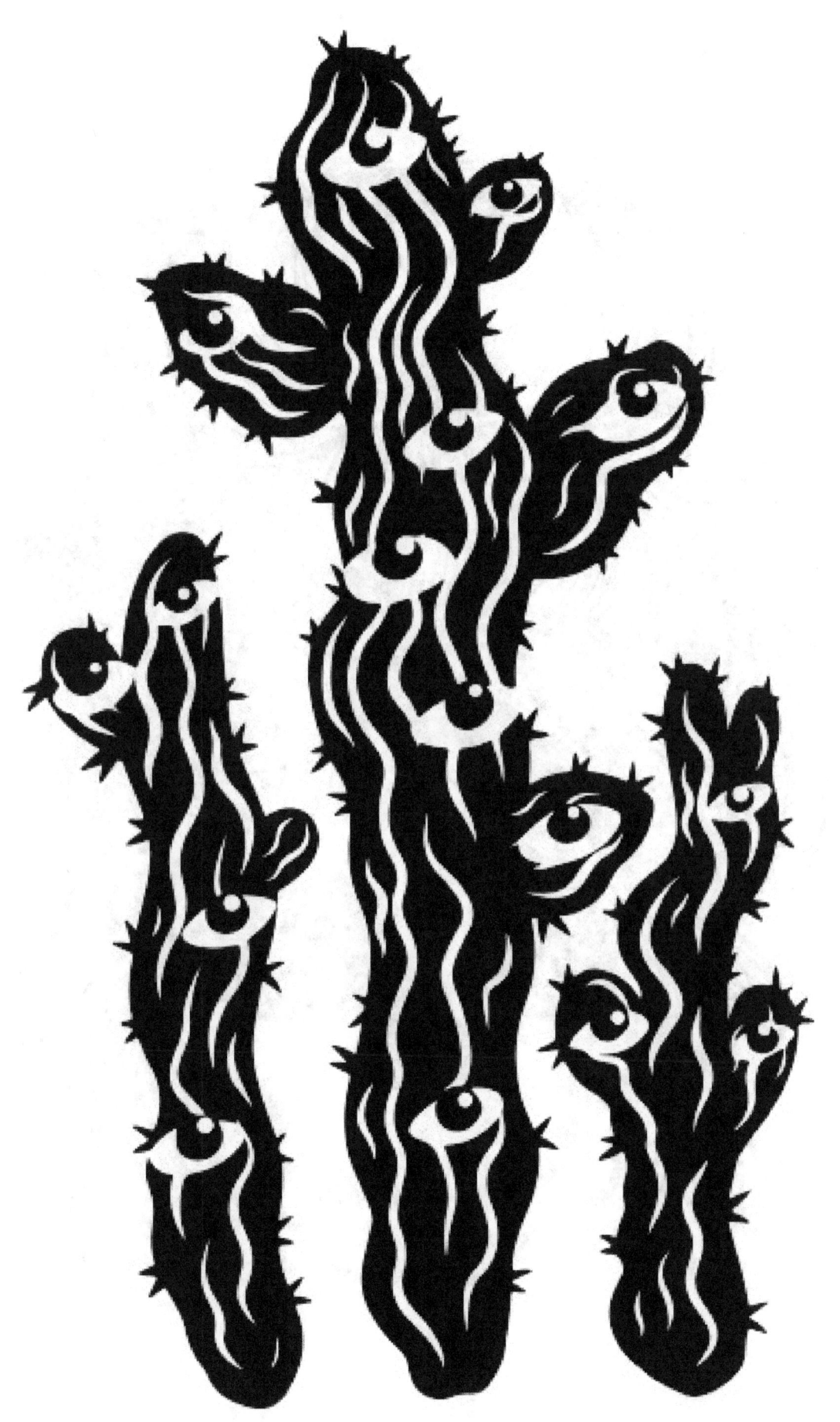

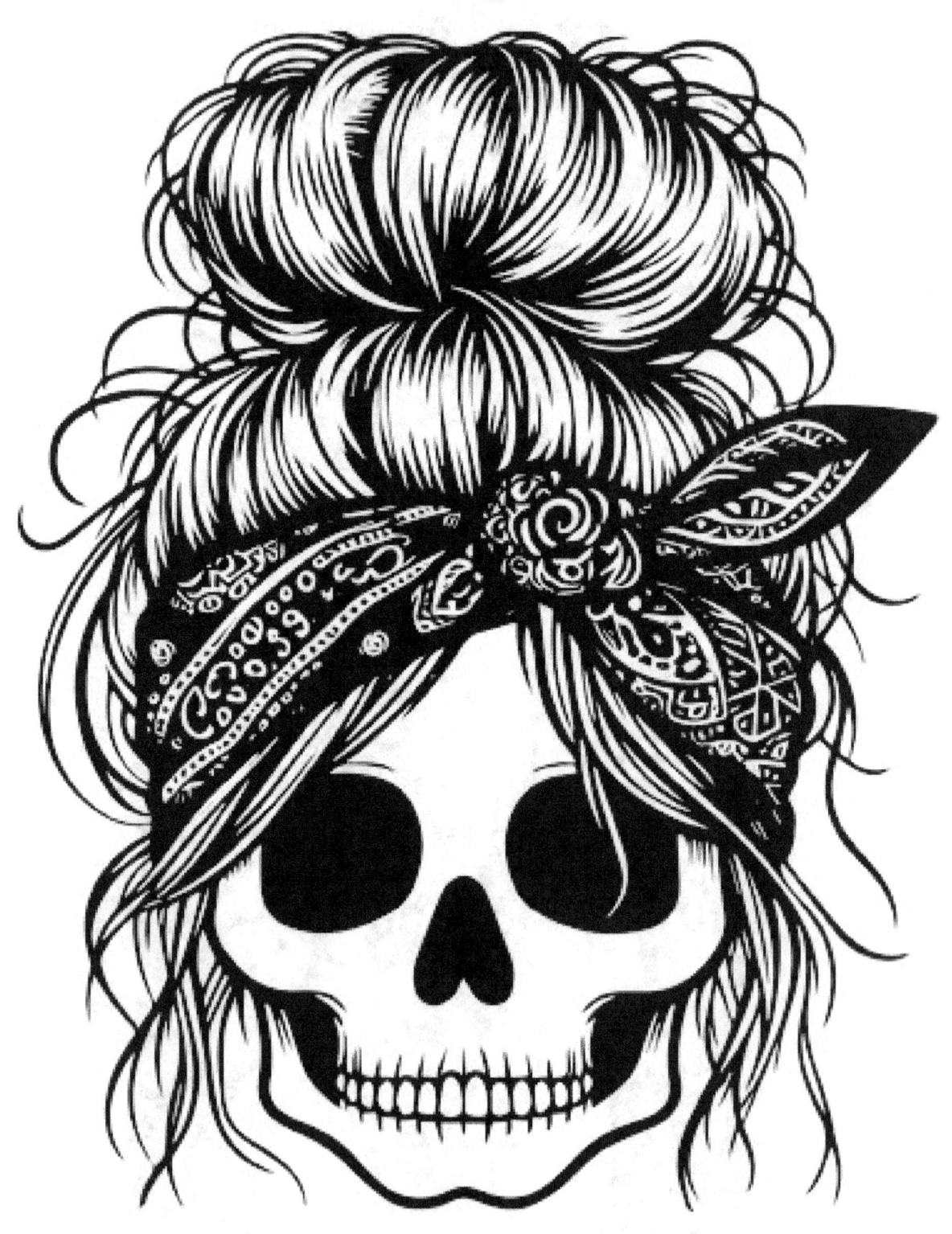

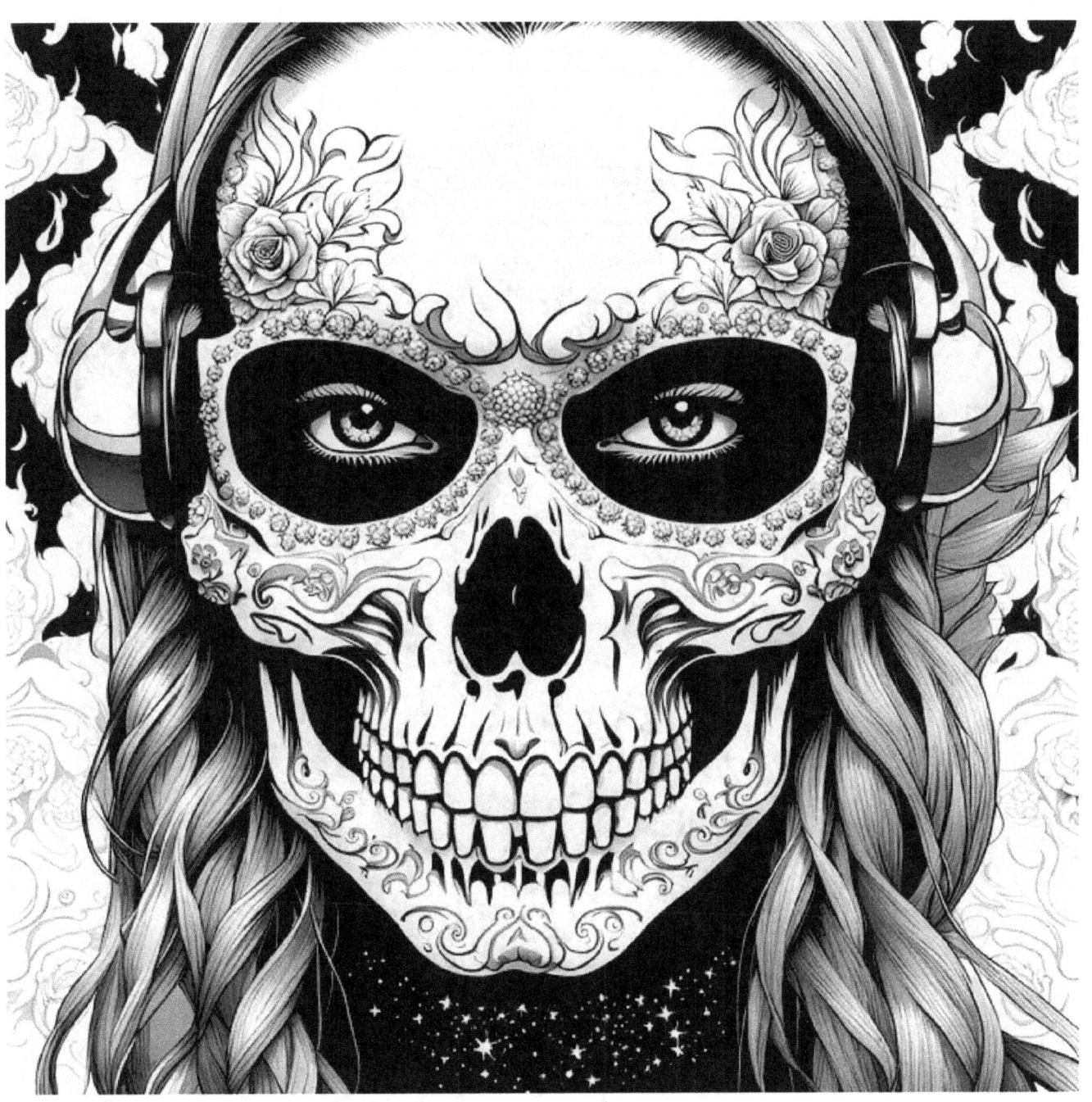

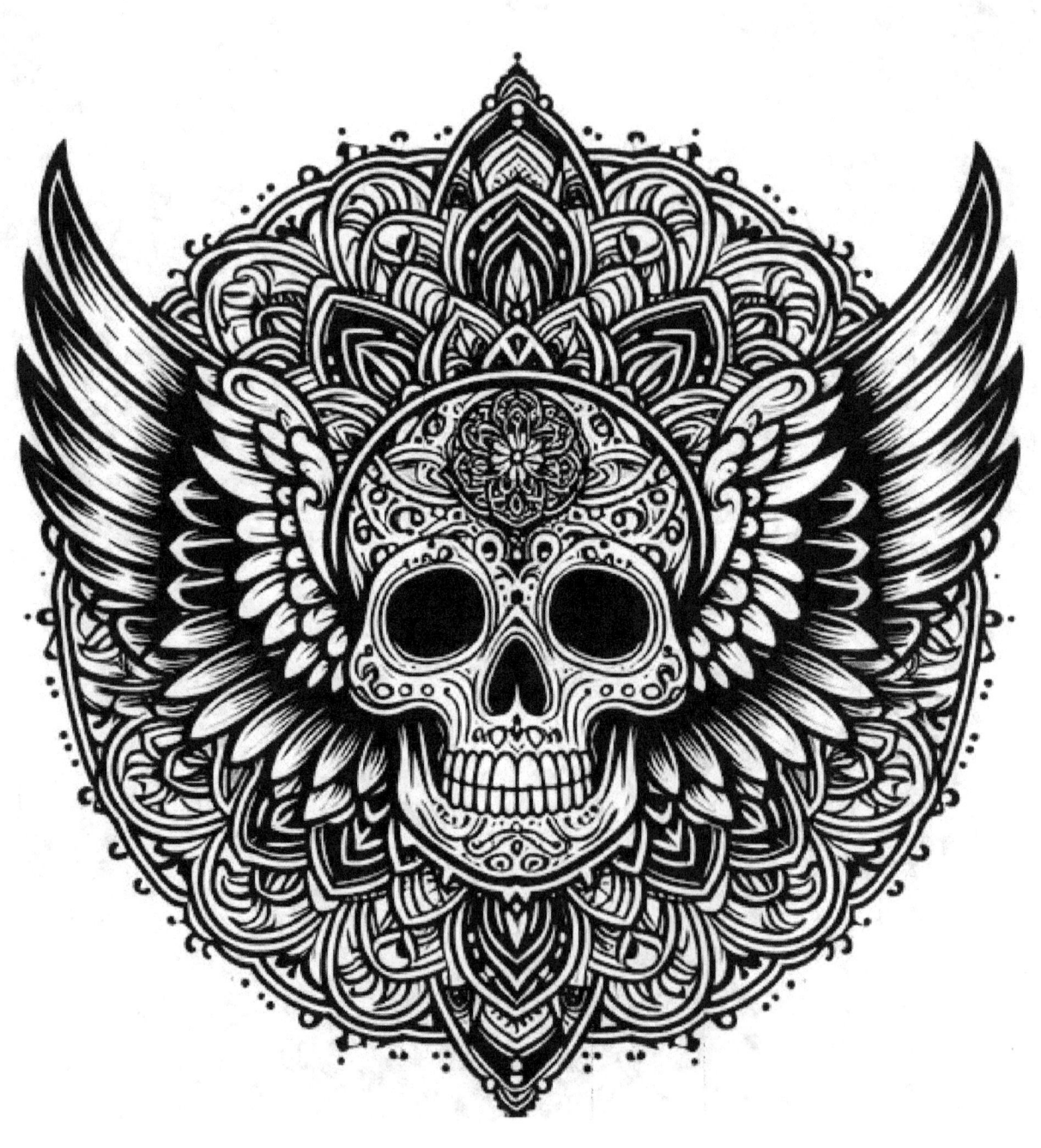

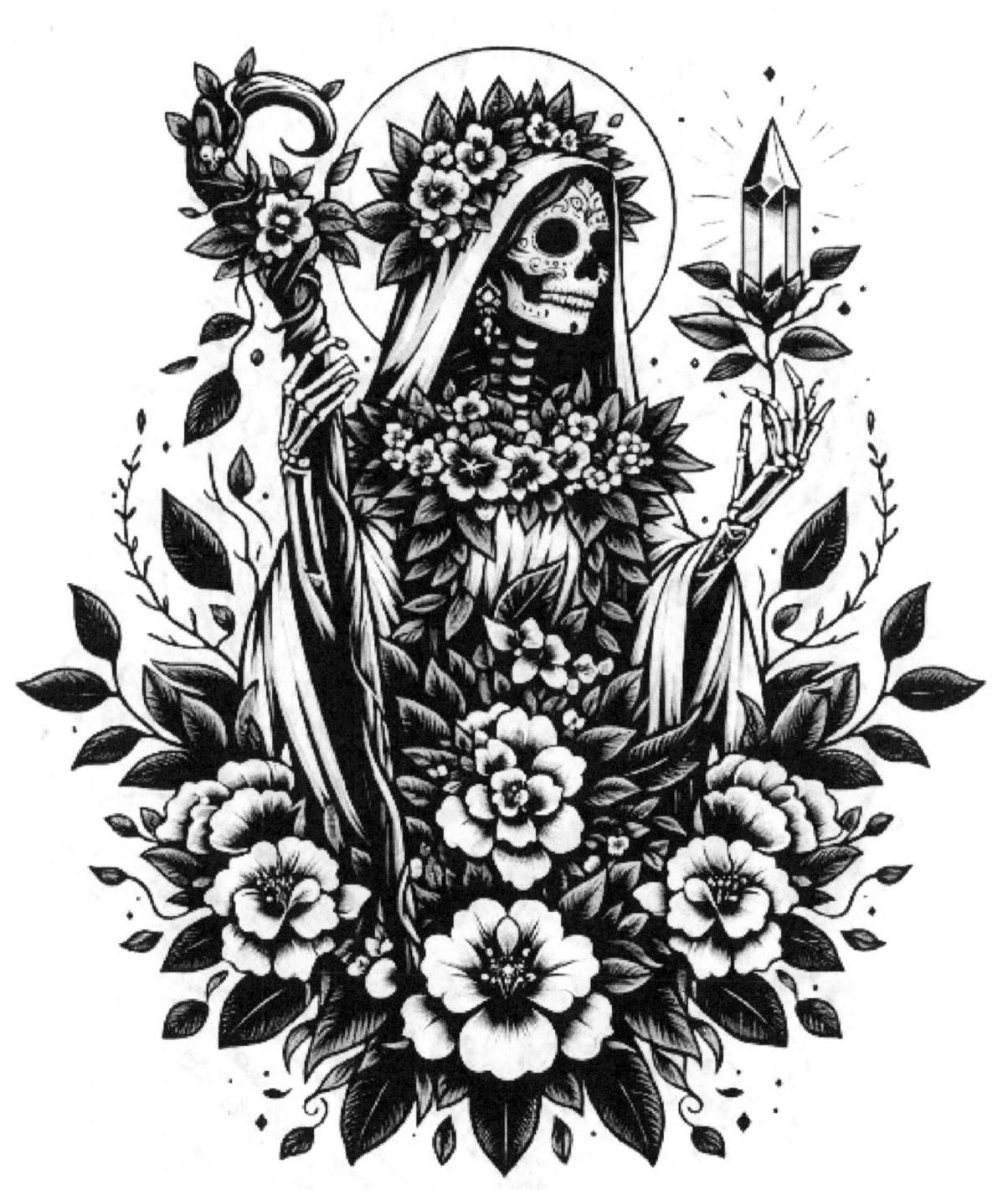

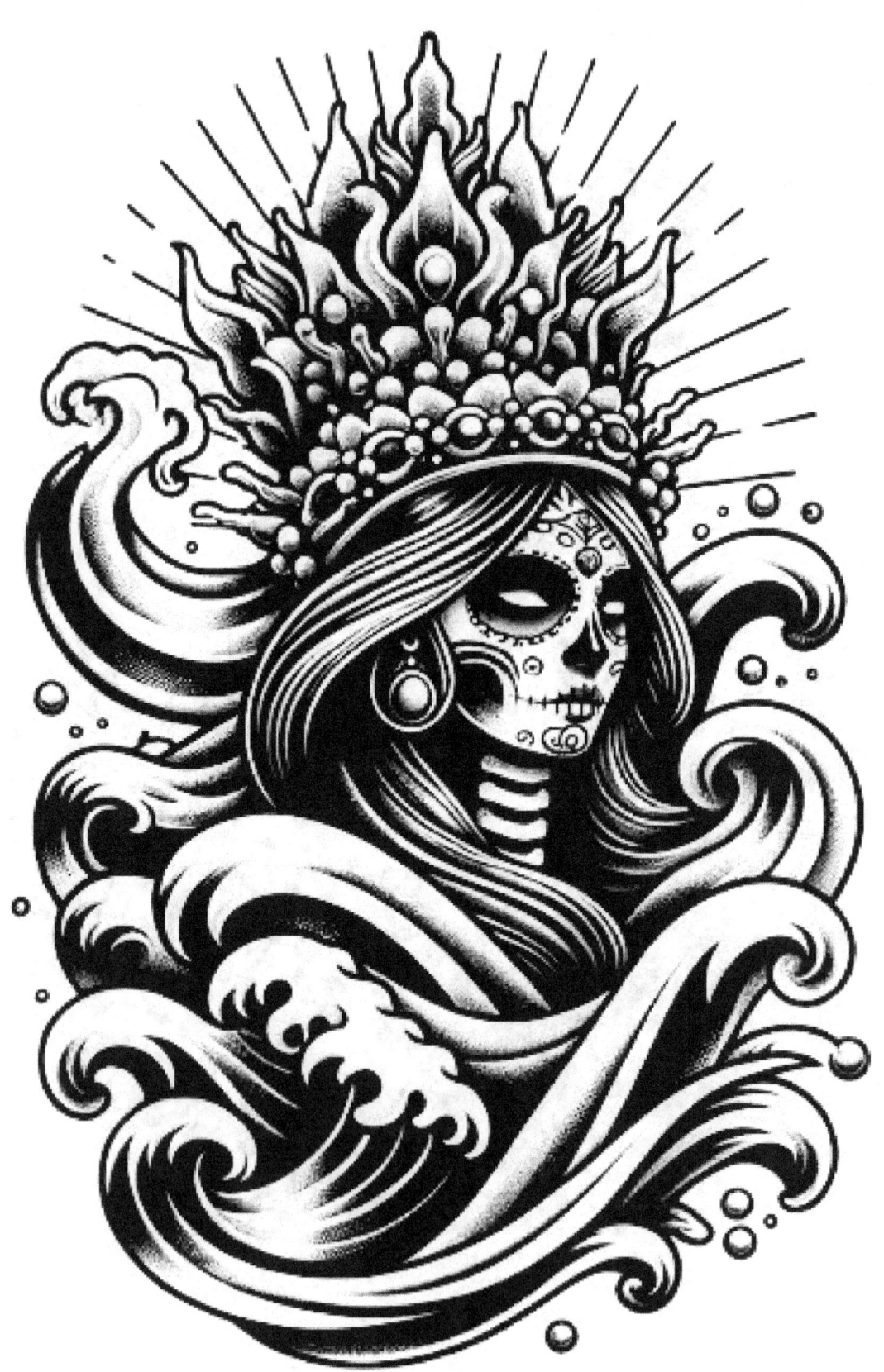

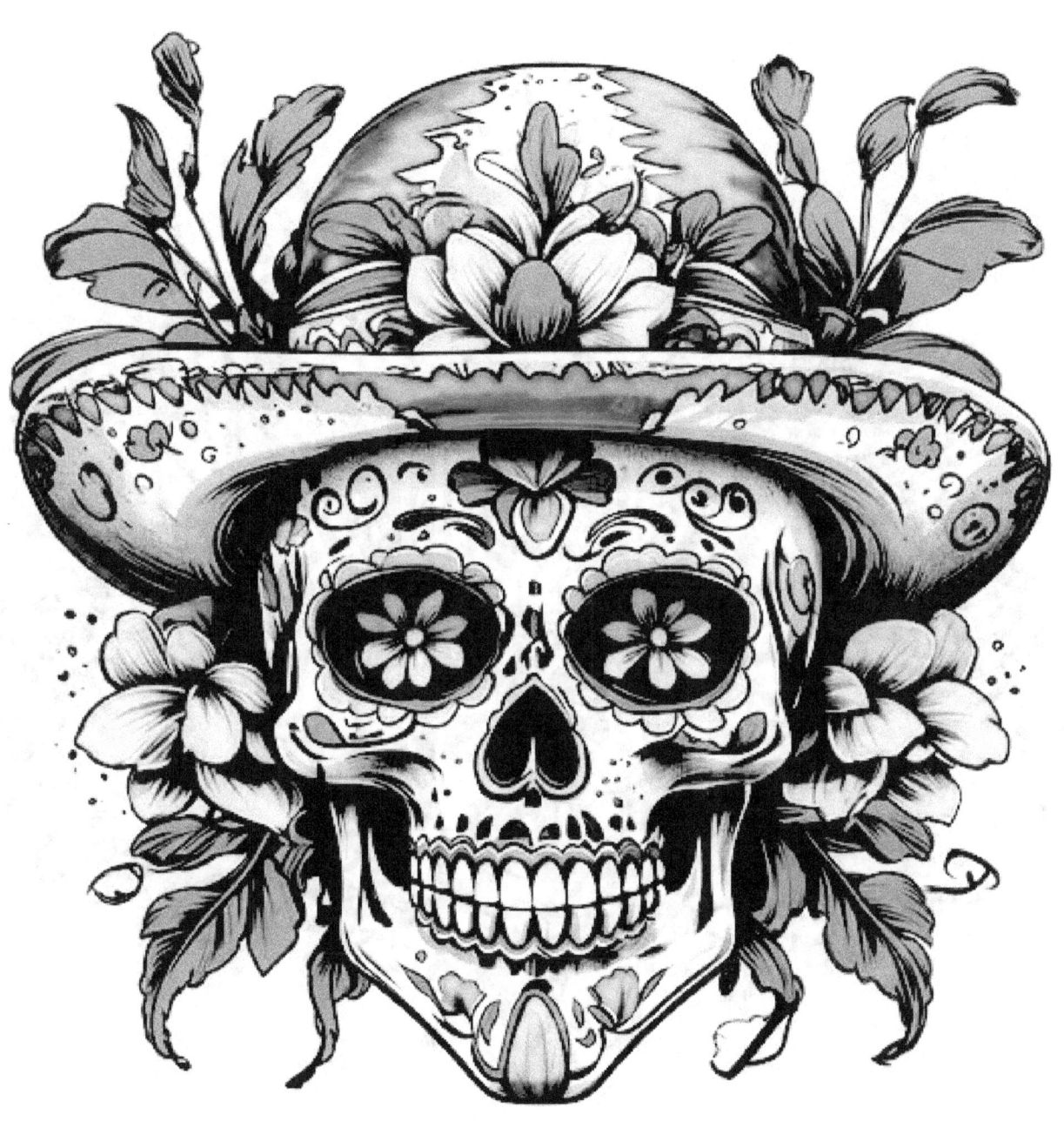

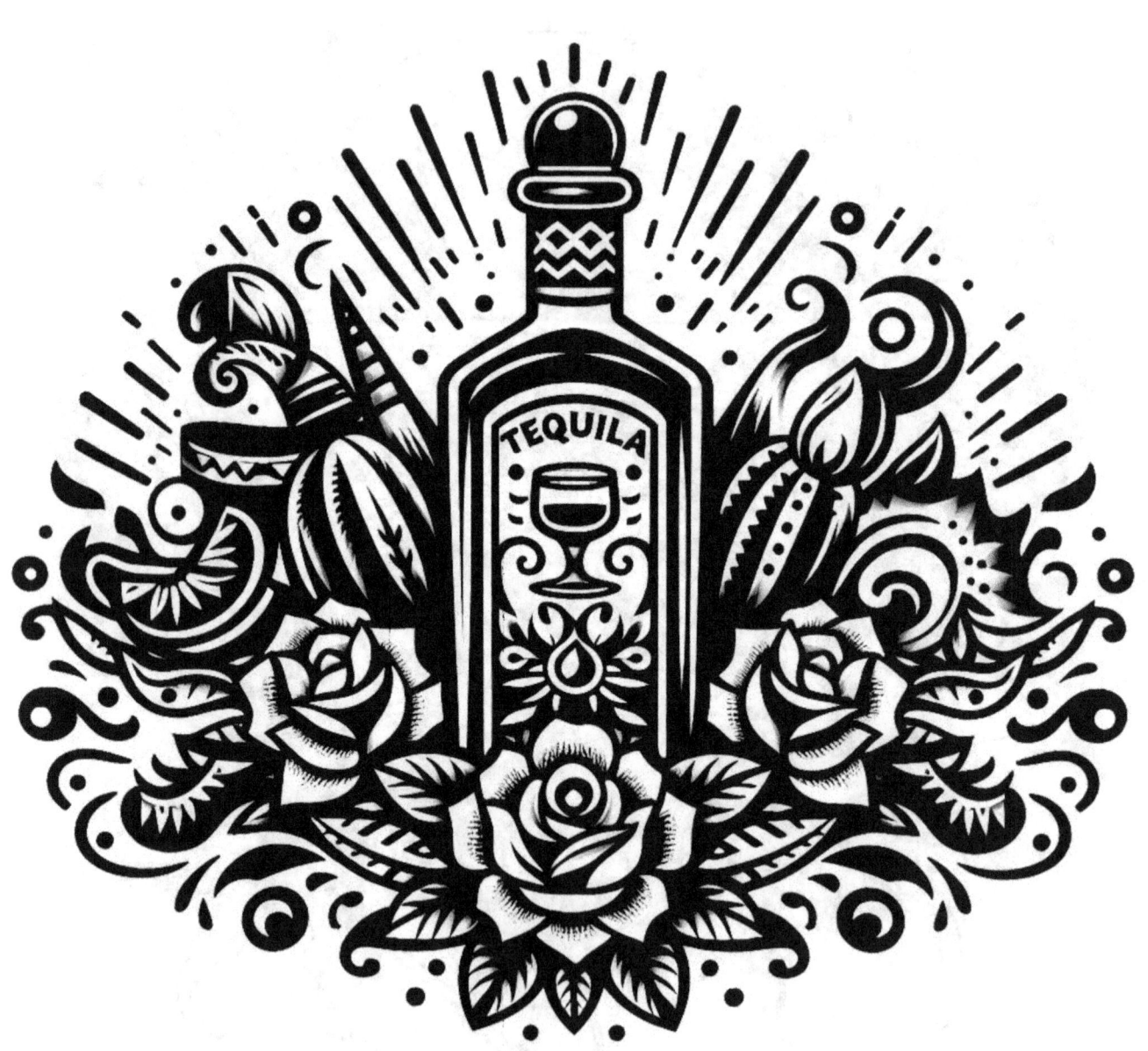

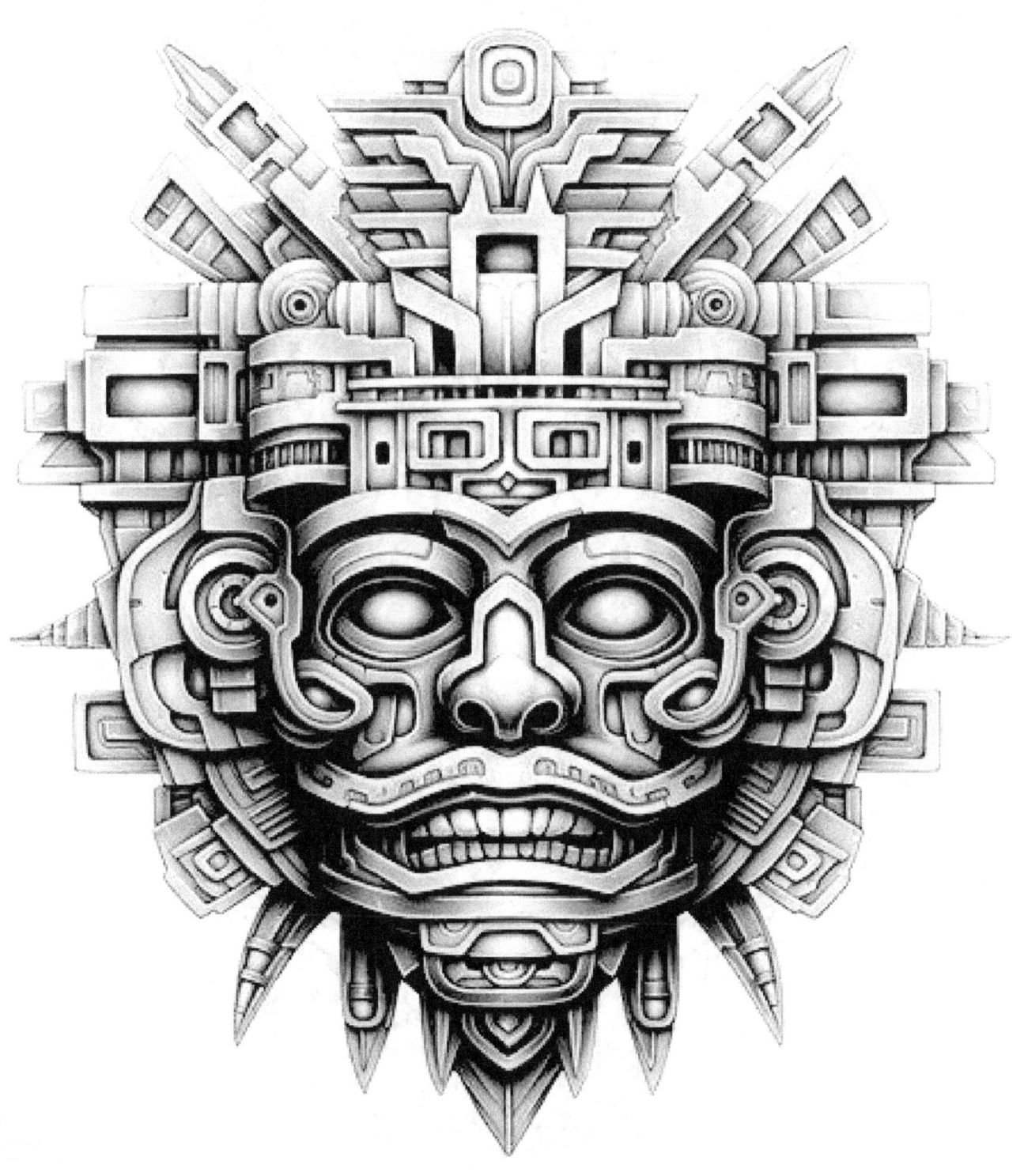

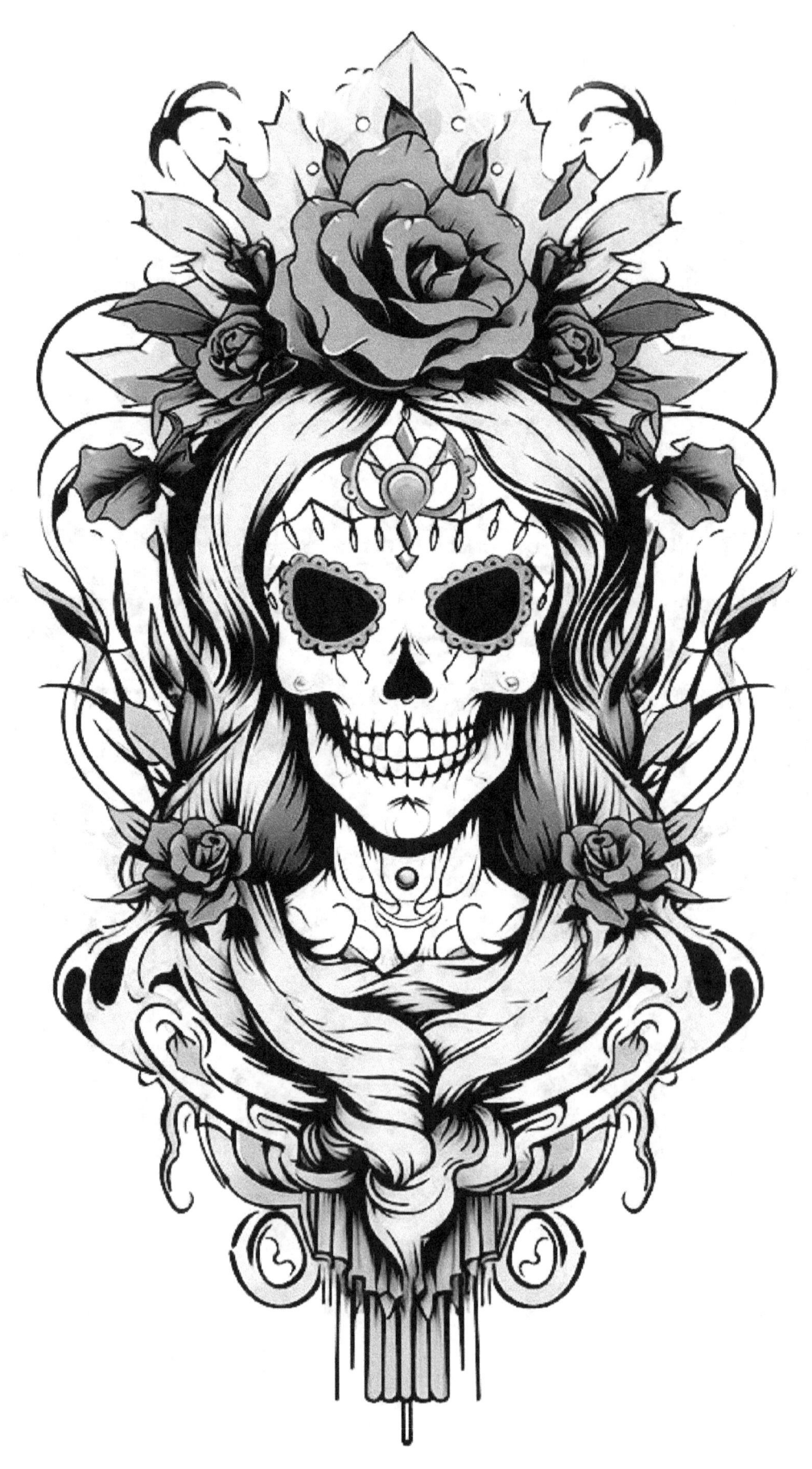

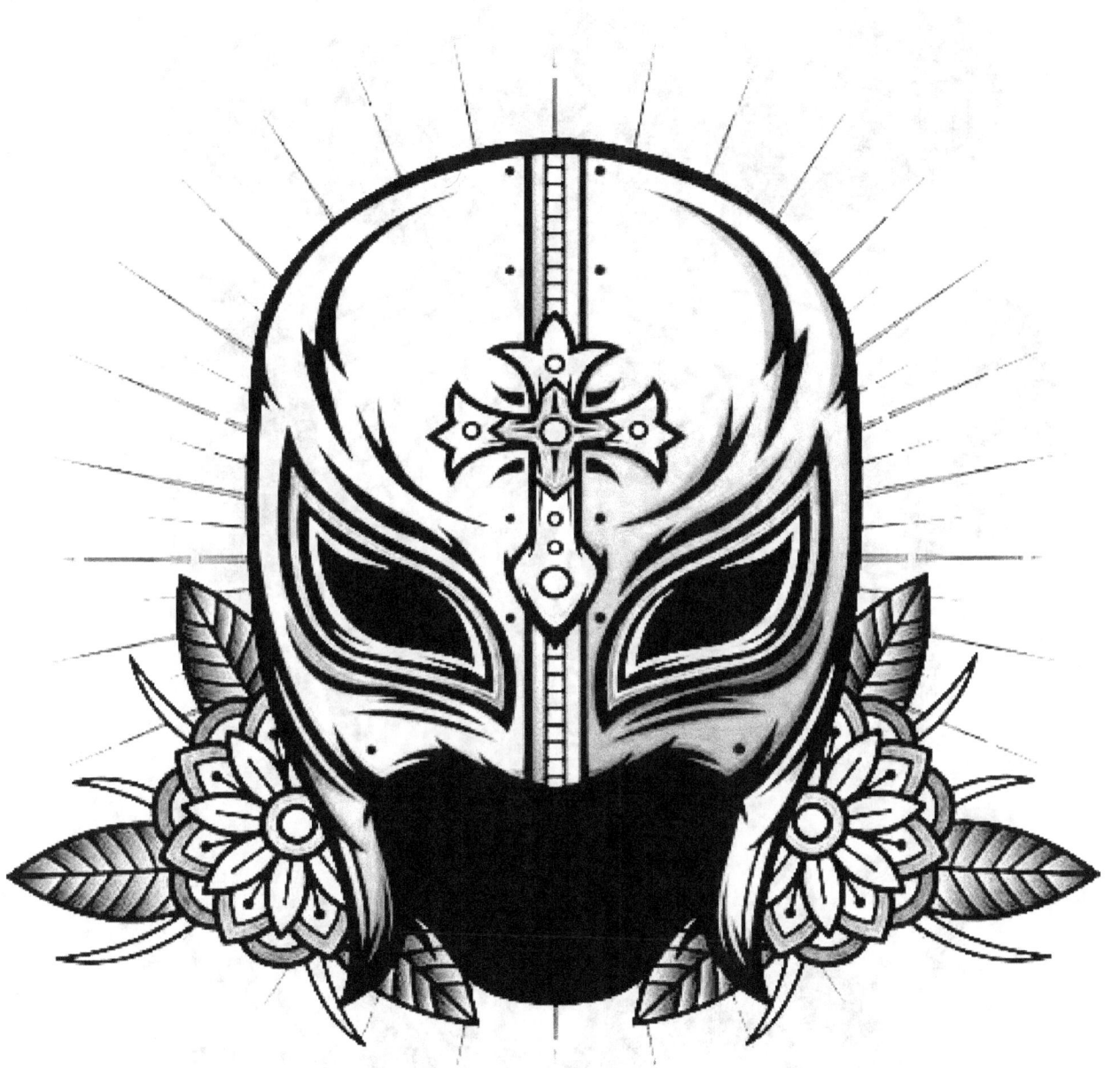

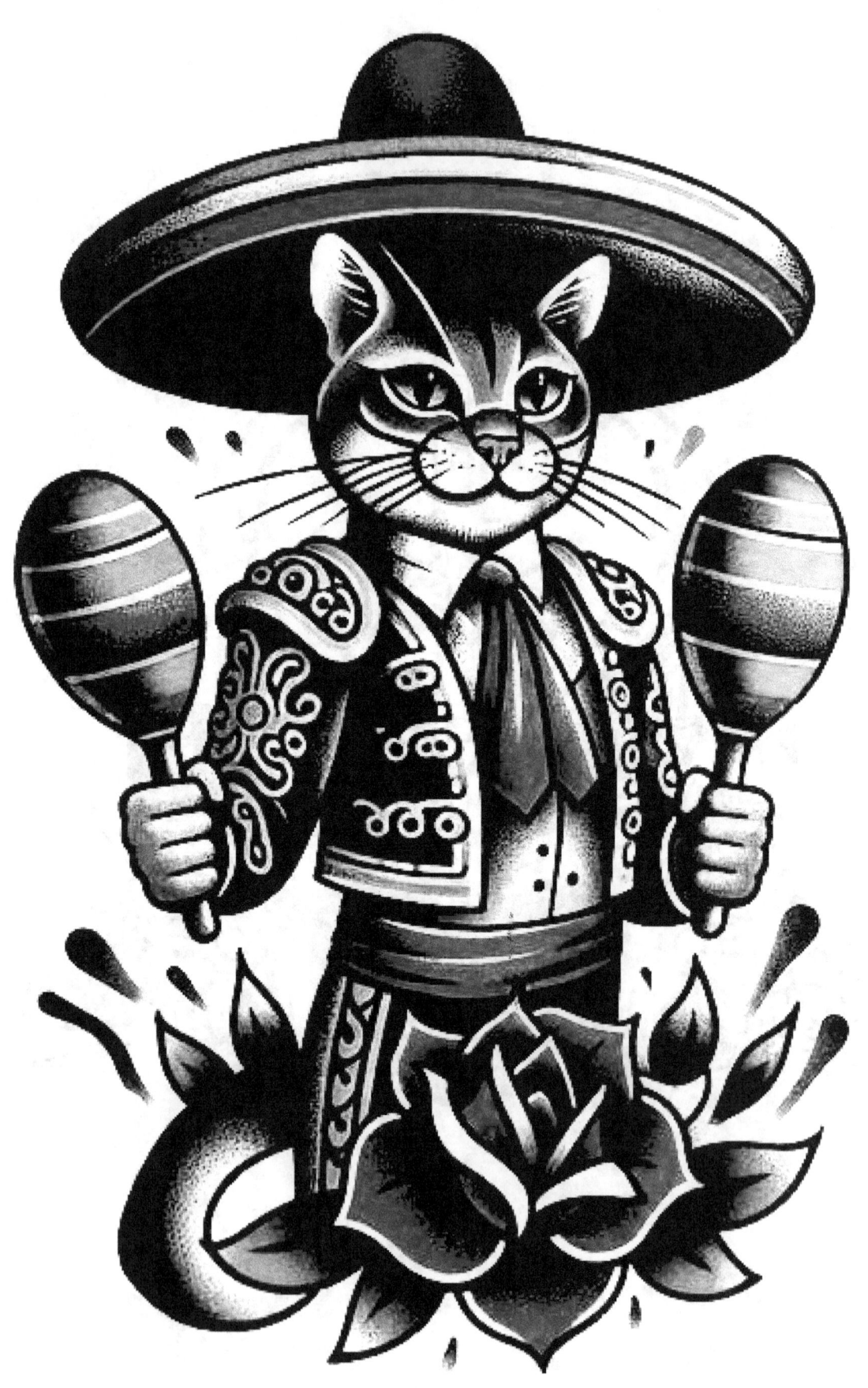

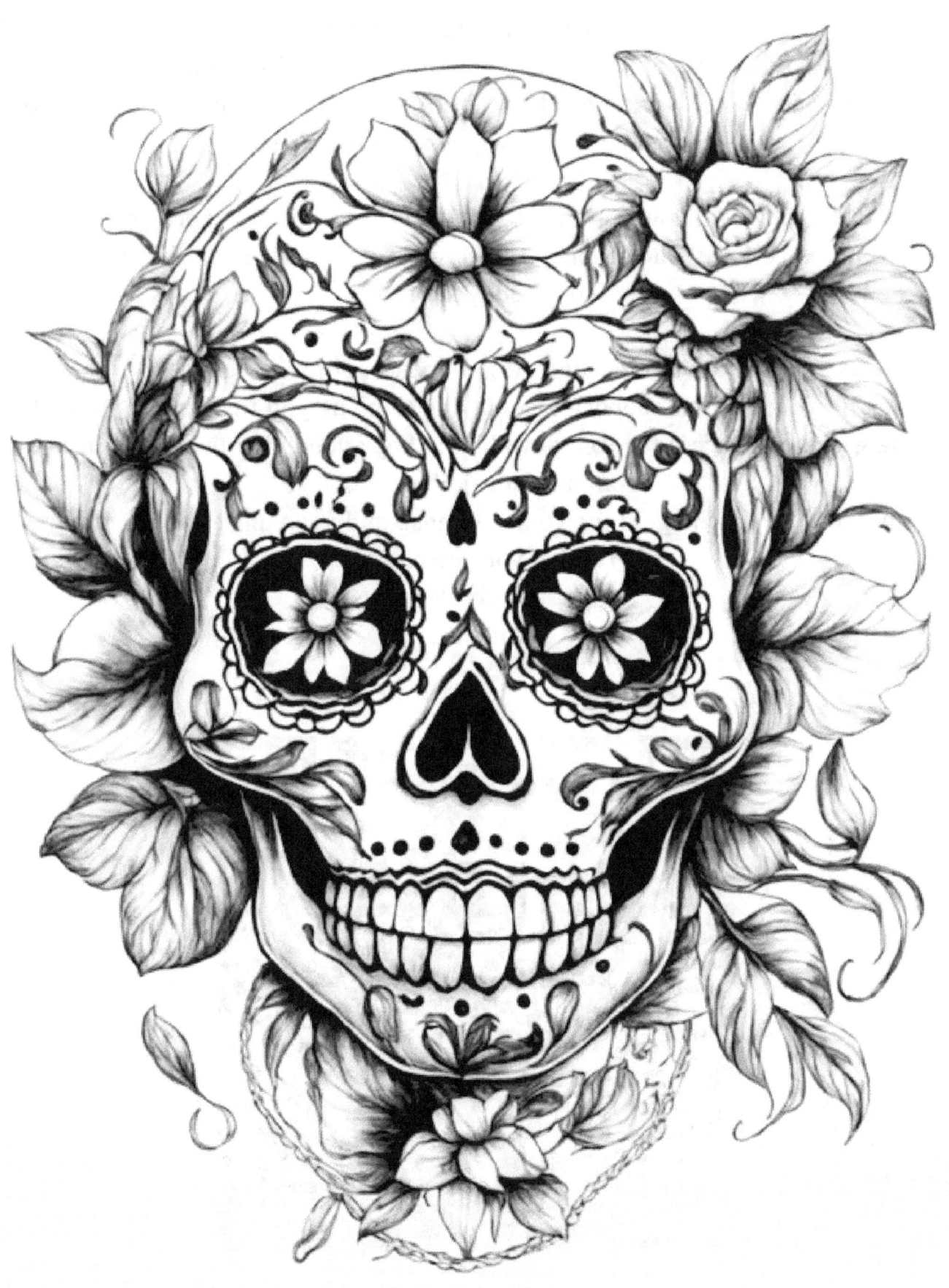

Thanks for your purchase

Thank you very much for purchasing one of my books! I am glad to know that you have enjoyed my work and I hope that you have found in it the inspiration and knowledge you were looking for.

If you are happy with your purchase, I would love for you to share your opinion through a review. Your comments are very valuable to me and help me to continually improve.

Get a free small design book in pdf format.
To thank you for your support, I would like to invite you to scan the QR code where you can access the free download. I hope you enjoy this little gift and continue to enjoy my posts.
Thank you very much again for your purchase and your time! I will be happy to receive your comments.
Sincerely,
Analía...

www.ingramcontent.com/pod-product-compliance
Lightning Source LLC
Chambersburg PA
CBHW082239220526
45479CB00005B/1277